D1463789

MAP COVER ART

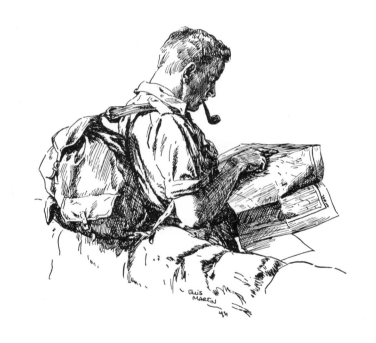

MAP COVER ART

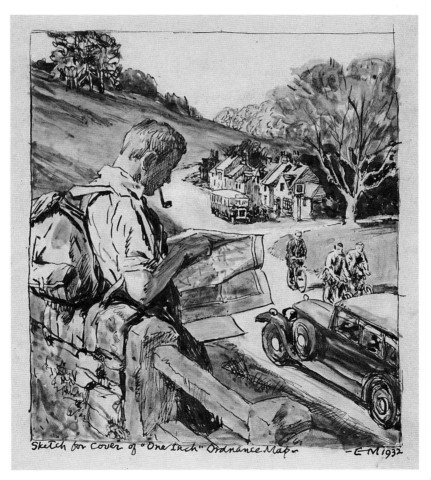

Sketch for Cover of "One Inch" Ordnance Map. —E·M 1932

John Paddy Browne

ORDNANCE SURVEY

BIBLIOGRAPHY

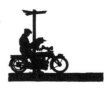

BOARD, Christopher, *The Quarter-inch Map* (Sheetlines – Newsletter of the Charles Close Society – No 9, April 1984

BROOME, Michael, *One-inch Seventh Series Maps: A Preliminary Listing of Cover Designs* (Sheetlines No 13, August 1985)

BROWNE, John Paddy, *The Ordnance Survey's Other Artists* (Hampshire Magazine, November 1982)

BROWNE, John Paddy, the same essay reprinted with different illustrations (Sheetlines No 6, April 1983)

BROWNE, John Paddy, *Forgotten Artists Who Showed the Way* (The Scotsman, September 1985)

BROWNE, John Paddy, *Ellis Martin and the Rise of Map Cover Art* (The Map Collector, June 1986)

BROWNE, John Paddy, *The Ordnance Survey's Christmas Cards* (Sheetlines No 17, December 1986)

CRUICKSHANK, John and David Archer, *Ordnance Survey Covers: A Glossary of Terms* (Sheetlines No 18, April 1987)

DREWETT, B.D., *The Map Market in Britain* (Professional Papers No 28, Ordnance Survey, 1975)

GARDINER, Leslie, *Bartholomew 150 Years* (John Bartholomew and Son, 1976)

GOSSOP, R.P., *Ellis Martin* (The Newsbasket, August 1912)

HELLYER, Roger, *The Archaeological and Historical maps of the Ordnance Survey* (Cartographic Journal Vol 26, December 1988)

MESSENGER, Guy, *The Ordnance Survey One-inch Map of England and Wales – Third Edition, Large Sheet Series* (Charles Close Society monograph, 1988)

MUMFORD, Ian and Peter Clark, *Marketing of Maps Before 1918* (Sheetlines No 15, April 1986)

NICHOLSON, T.R. Wheels on the Road: Road Maps of Britain 1870-1940 (Geo Books, 1983)

NICHOLSON, T.R. *Ordnance Survey Cover Designs for District Tourist and Miscellaneous Maps 1898-1939* (Sheetlines No 19, August 1987)

NICHOLSON, T.R., *Lies, Damned Lies and Imprints! Some Tourist and District Map Anomalies 1919-1940* (Sheetlines No 11, December 1984)

NICHOLSON, T.R., *Tourist Maps and the One-inch District Maps First Issued 1913-1938: An Introduction* (Sheetlines No 12, April 1985)

OLIVER, Richard, *A Guide to the Ordnance Survey One-inch Fifth Edition* (Charles Close Society monograph, 1987)

OLIVER, Richard, *A Guide to the Ordnance Survey One-inch New Popular Edition and Scottish Popular Edition* (Charles Close Society monograph, 1987)

Public Record Office Ordnance Survey files OS1/216, 258, 307, 395, 396, 397, 751, 979 (Public Record Office, Kew)

Progress Report (Ordnance Survey, March 1921)

Report of the Departmental Committee for the Sale of Ordnance Survey Maps (The Fisher Report) HMSO, 1896

Report of the Departmental Committee on the Sale of Small-scale Maps (The Olivier Report) Confidential Papers, Board of Agriculture and Fisheries, 1914

SEYMOUR, W.A., (Ed), *A History of the Ordnance Survey* (Dawson, 1980)

SMITH, David, *Victorian Maps of the British Isles* (B.T. Batsford, 1985)

Ordnance Survey Map Cover Art

Text © Ordnance Survey
List of Covers © Roger Hellyer

Illustrations, except where otherwise indicated © Ordnance Survey

British Library Cataloguing in Publication Data

Browne, John Paddy 1939–
 Map cover art: a pictorial history of Ordnance Survey cover illustrations.
 1. Great Britain. Maps, illustrations
 1. Title
 741.6

ISBN 0–319–00234–9

Printed and bound in Great Britain by Butler & Tanner Ltd, Frome and London

This bibliography is selective; many more pages of these and other publications carry further details of Ordnance Survey Map Cover Art, but such details may be confined to minor aspects of cover art such as price changes, changes of monarch and alterations to map titles

CONTENTS

For my mother,
Mary Josephine Browne

ACKNOWLEDGEMENTS

I have to thank Margaret Webb, Susan Verstage, John Elcock and Maureen Wing for information on the private life of Ellis Martin; T.W. Baker-Jones, Archivist at W.H.Smith and Son, for unearthing some of Martin's pre-Ordnance Survey artwork; Francis Herbert of the Royal Geographical Society for details of the *Carte du Monde au Millionième*; Jean Hill, wife of the late A.T. Chester; and David Ball, formerly of the Ordnance Survey's Archaeology Division and the Royal Commission on Historical Monuments, for details of Chester's work.

Harry Titcombe, who decorated the Ordnance Survey's Outdoor Leisure Map series with his fine ornithological drawings, responded helpfully and courteously to all my questions concerning his work.

The Public Record Office staff at Kew were unstintingly helpful; so, too, were many members of Ordnance Survey staff, both active and retired, who raked over the embers of memory to recall their early years with the Department.

Lord Moyne (the poet and writer, Bryan Guinness) gave permission to reproduce his poem *Hampstead Eclipse 1927*; and Ronald V. Tooley, 'the Grand Old Man of Maps', wrote encouragingly when he heard of my early work on this book. It is my deep regret that he did not live to see it completed.

Much of the original cover art reproduced in this book is preserved in private collections, and I am grateful to its owners for access to it and for their permission to use it here. Most of the newer artwork is housed at the Ordnance Survey's headquarters in Southampton, and is used by permission.

An important part of this book is the List of Ordnance Survey covers which follows the last chapter. Although not claimed as definitive, it is nevertheless an attempt to record all the map covers we have seen in which artistic skills have been brought to bear. Photographic and letterpress covers have, therefore, been largely excluded from this List.

Apart from my design of the List, and a few meagre details contributed

by me, the List is the work of Roger Hellyer M.A., D. Phil. (Oxon), F.R.C.O. Dr. Hellyer and I wish to acknowledge the contributions made by David Archer B.A., Dip. Lib., D.M.S; Guy Messenger M.A. (Cantab.), F.L.S; Tim Nicholson M.A. (Oxon.), Ph. D., F.R.G.S; Richard Oliver B.A., D. Phil; Nick Savage B.Sc; and those who generously gave information and allowed their collections of maps to be inspected.

The first typescript was made by Sheila Knight who had the forbidding task of deciphering my barely legible handwritten copy. She deserves a medal for assiduity.

Drs. Hellyer and Nicholson also read this first typescript and made comments sufficiently helpful to have saved me from some embarrassing lapses. I am grateful to them both for their unflagging help and support — and entertaining companionship during the telling of this story.

And finally I wish to thank my friends and colleagues at the Ordnance Survey who have, in one way or another, been involved in the production of this book. I know who you all are, and you know who you are, and it is only the exigencies of economic need which prevent all your names appearing here, for the list would indeed be a long one.

Winchester John Paddy Browne
Hampshire, 1990

FOREWORD

'All art', said Oscar Wilde, 'is quite useless. Art never expresses anything but itself.'

Oscar Wilde was wrong in this instance, however wise and perceptive his other epigrams may have been. For the art used by the Ordnance Survey on its map covers, since the end of the First World War, has been a vital factor in the promotion and propagation of the Department, helping to make OS maps part of the British way of life. And just as all criticism is relative, so are the standards by which we judge art. I make no extravagant claims for the art used by the Ordnance Survey, and when I use terms such as 'great' or 'superb' in this book, such terms must of course be seen in the context of commercial art.

Although this is a book about Ordnance Survey map cover art – that is, the work of the artists who designed pictorial covers for Ordnance Survey maps – it would be a missed opportunity were we not to include examples of the artists' work which was never published as map covers. This work falls into four categories: 1. Work which was designed for use as map covers but never used as such; 2. Work which was not necessarily designed for use on a map but which had some use in the promotion of maps and map sales; 3. Work which has no direct relevance to maps (e.g. Ordnance Survey Christmas cards); and 4. Work which helps us to see the cover designers as recreational artists, as freelance commercial artists, or as innovators of style.

When we pick up a map in a bookstall, almost the first thing we do is to open it out, paying scant attention to any design – however attractive – there may be on the cover. But the cover has already done its job: it made us pick up that particular map in preference to any other map of the same area. This is part of the cover artist's skill – to influence a customer's choice, to draw the eye to a certain product, and to make that product so attractive and promising that it is picked up. From that moment onwards, the cartographer's art takes over. But that is another story . . .

Nowadays the Ordnance Survey tends to use photographs on the covers

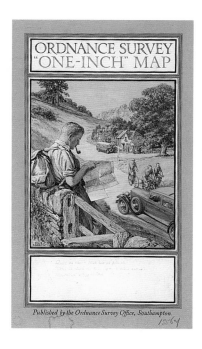

of its maps and books. But in the earlier years of the Department, artwork – frequently of a very high standard – was used to lure the potential customer's eye to Ordnance Survey products. Although generations of us have taken for granted the work of this small band of cover designers, it is now eagerly sought after by a growing number of collectors. Ordnance Survey original cover artwork commissioned by the Ordnance Survey now turns up, infrequently, in art shops, second-hand map and book shops, ephemera society gatherings, antique shops, and the like. Sometimes it is offered to collectors in conspiratorial no-questions-asked telephone deals which rather exaggerate the actual value of the work.

In recent years, the Ordnance Survey has taken more care to preserve and record its original treasures. While map cover artworks may not merit the same treatment as Old Masters, they are nevertheless unique documents and, as part of the Ordnance Survey's vast output of work of all sorts, warrant careful protection and preservation. Commercial dealers and opportunist entrepreneurs – for all their other practices – have at least looked after some of this material when it has fallen into their hands. They know that collectors with sufficient funds are often prepared to pay an inflated price for it.

In too many cases, however, this book will be the only record that such fine work ever existed.

Classic Ordnance Survey map cover of the 1930s, by Ellis Martin

INTRODUCTION

T HE ORDNANCE SURVEY CAME INTO being in 1791 but had its genesis in the fifty years before that date. The second Jacobite rebellion of Charles Stuart (Bonnie Prince Charlie) had revealed quite graphically the shortcomings of existing maps of the time to an army on the march – or in retreat for that matter. In the aftermath of the rebellion, a young man called William Roy was made responsible for producing a new, military-oriented map of Scotland.

Roy envisaged a mapping programme which would reach beyond his native Scotland, and he promulgated the idea of a national survey covering the whole of Britain. It was not until military necessity diverted attention from Scotland to the south coast of England, and the threat of invasion by France became very real, that a formalised programme of small-scale survey was finally initiated.

The history of that elaborate project is well documented elsewhere and this is not the place to dwell upon the science of map-making. But a brief resumé is useful.

The One-inch map of Kent, first published in 1801, was produced under the aegis of the Board of Ordnance. From it sprang a systematic survey of the entire country. Roy had not lived to see his vision come to fruition, but he is popularly regarded as the 'father' of the Ordnance Survey, although the Duke of Richmond, as Roy's scientific patron, is probably the man most responsible for the institution of the national survey.

Since that time other military and political exigencies have diverted the Ordnance Survey's attentions. The era following the Irish rebellion of 1803, for example, brought almost the entire staff of the Ordnance Survey to Ireland. Initially their task was to produce a cadastral survey of the country's boundaries for a reform programme of land classification and taxation. Later the cadastral survey was overtaken by a topographical survey in which many of today's Departmental policies were tried and tested, among them the development of the Six-inch scale, and the introduction of the 'Object Name Book'. The information collected for these name

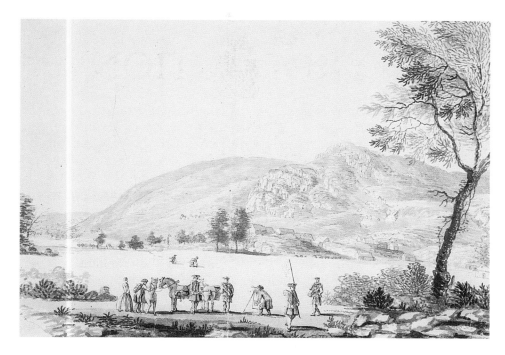

Paul Sandby RA: *Surveyors at work in the Highlands*, c 1749

books was, in the case of the Six-inch survey of Londonderry, expanded into a massive 'domesday' survey of Londonderry which was published as a Memoir of the city. No further memoirs were ever published during the Ordnance Survey's operations in Ireland, but the name books have survived and, more than a century later, remain a rich source of information for the study of placename orthography.

The First World War took the Ordnance Survey overseas and into the front line, where a number of the Department's military staff were to lose their lives. A pair of handsome stained-glass windows were subsequently erected in the Southampton offices at London Road to commemorate those members of staff who died between 1914 and 1918. When, twenty years later, another world conflict came to Britain, those windows were destroyed in the German bombing raid which devastated a large part of the town and the Ordnance Survey offices on the night of 30 November, 1940.

As well as the windows, which had been designed by an artist whose name is to appear frequently in this book, much original map cover artwork was lost in the Blitz. Consequently, most of the examples of this artist's work reproduced here are taken from printed map covers, posters and hand-bills. Some pieces of original work did escape the bombing raids, and collectors of Ordnance Survey ephemera continue to search for it with much optimism.

War damage is not the only problem which hinders research into the map cover art of the Ordnance Survey. The task is often frustrated by erratic departmental records. Internal office files, mostly now deposited with the Public Record Office, have been raided by earlier users and have had examples of artwork and proofs removed. Minutes are frequently incomplete, suggesting that decisions to commission and select artwork were sometimes made off-file. The names of the artists are hardly ever mentioned and, as the Department evolved administratively, so section and post nomenclature have changed, adding further difficulties to research.

Artwork, whether published or unpublished, can usually be identified by the names or initials of the artists: in the early days the Ordnance Survey had not imposed its rule of anonymity and individual staff could occasionally leave their mark on their own work. In the case of original artwork there is the advantage of seeing the artists' instructions to plate makers and printers pencilled in as marginalia. The harmless artistic jokes, which are something of an Ordnance Survey tradition, can also help the researcher to identify individual work. Finely penned or engraved personal names, initials or 'trade marks', are sometimes hidden among close detail and ornament, and these can be detected by the hawk-eyed or by close scrutiny with a magnifying glass. The finest piece of the research jig-saw is the evidence of contemporary colleagues and family descendants. Interviews with former members of staff who knew some of the artists during their years with the Department, and their eye-witness accounts of the artists at work, have added life to the figures mentioned in official files. Relatives of the artists have been generous with their time and patience, and in lending examples of artwork for reproduction in this book.

This is an appropriate place to sound a word of warning about publication dates. The general rule of thumb is that it is impossible to tell the date of a map's publication from its cover, and vice versa. To embark on a study of Ordnance Survey publication dates is to enter a labyrinth full of trip-wires for the unwary. Nowadays we know what we mean when we talk about 'Editions' and 'Series'; a 'Series' is a map (of whatever scale) which is produced to a set specification. An Edition is a variation of that map within the specification – that is, the map could be a revision or a facsimile reproduction, but it is not significantly different in style or format from the edition which it supersedes.

In the Ordnance Survey's early days things were not so clear cut, and the words 'Series' and 'Edition' were used indiscriminately. The One-inch map, for example, went from First Edition (the so-called Mudge map of 1801, which was a one-off, unnumbered sheet) to the First Edition or 'Old Series' large and quarter-sized numbered sheets, to the Second Edition or

'New Series' small numbered sheets, to the New Series First Revision, to the New Series Second Revision which was also called the Third Edition, to the Fourth or 'Popular' Edition, to the Fifth Edition, to the Sixth or 'New Popular' Edition, to the Seventh Series. Within these confusing titles there were further complications in the form of coloured editions, hachured, relief, contoured and outline editions. There were also 'Tourist' and 'District' and 'Special Area' maps – compilation maps with sheetlines distinct from the regular series, and all of them genetically called 'the One-inch map'.

Part of the 'Mudge map' – the first Ordnance Survey One-inch map of Kent, 1801

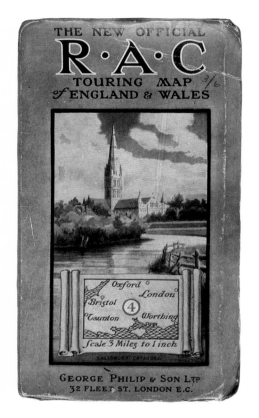

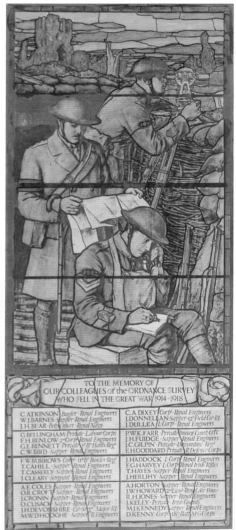

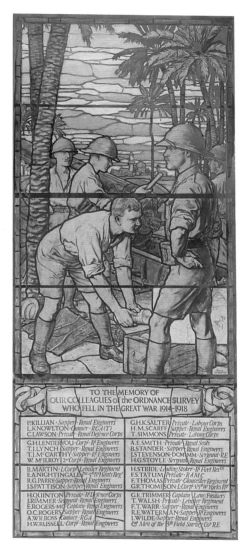

Above: Commercial map showing the early influence of the Ordnance Survey's new cover designs (Courtesy RAC)
Right: War Memorial windows designed by Ellis Martin, commemorating Ordnance Survey staff who lost their lives in the Great War

At one time during the 1930s and 40s the One-inch had become such a complicated maze that it was impossible to produce an Index, and a cartouche replaced the traditional Index on the outside back covers of One-inch maps.

Then, when the Ordnance Survey adopted the innovation of pictorial covers, the new covers were sometimes pasted on earlier editions in order to get rid of old stock. It is quite possible to find cover art on maps which had been printed and first published long before their designers even

worked for the Department.

The dates given against some of the artwork in this book have been arrived at after a considerable degree of head-scratching. The aim has been to identify the date of a picture's first appearance on a map cover or advertising poster, handbill or shop display card. Where possible the year in which the artist produced a certain piece of work has also been given. This can sometimes be deduced from the publication date of the map upon which the artwork first appeared. For example, we know that the first edition of the *Map of Roman Britain* was published in 1924, so it is safe to assume that the cover was drawn in that same year. The second edition of *Roman Britain* was published in 1928 and the artist made appropriate alterations to his original design for that edition in that year.

Cryptic entries in working files sometimes — but not often — announce the commission of a new cover design; and we have to rely on the introduction of a new series if we are to pin down the creation of a new standard cover.

All this may be unduly pedantic and beyond the interest of some readers. But to satisfy the appetite for such detail which certainly exists in other readers and collectors, every effort has been made to be as reliable as possible in the matter of dates.

The list of covers at the end of the book is an attempt at a comprehensive index of those Ordnance Survey covers in which certain artwork was a feature. It is offered as a springboard for further research by the more dedicated student.

The main purpose of this book, however, is to record a unique Ordnance Survey tradition and, in recording it, to please the eye. If the book does that, then it has achieved most of what it set out to do.

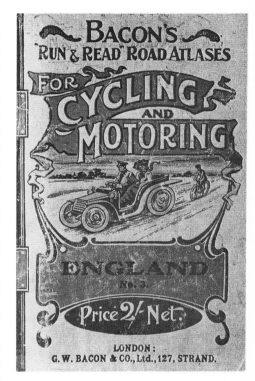

Early example of map cover art from a commercial publisher (Courtesy G W Bacon)

THE BACKGROUND

1914 WAS A WATERSHED YEAR in the fortunes of the Ordnance Survey. It was the year when decisions were taken which in time would change the image of the Ordnance Survey from that of an austere, scientific and aloof organisation into that of a commercially-minded vendor in the map market-place. The effects of those decisions are still with us today.

For although the Ordnance Survey now favours covers with photographic images and bold, unsubtle, but eye-catching typographic titles, rather than the brushwork of artists skilled in landscape painting and calligraphy, what we now buy in the shops is a product which has evolved directly from the ideas of a committee meeting held in 1914.

The story of Ordnance Survey map covers is the story of Ordnance Survey marketing. Looking at the pictures in this book is rather more interesting than reading about the changing techniques or policies for selling maps, but we should not ignore the fundamental purpose of map cover art. Attractive pictures were printed on map covers to sell the maps. That these pictures were so good in many cases is a bonus for us all.

This book is concerned with the covers which sell maps, and not with the maps themselves. The art of cartography – or the science, if you prefer, although the two elements are inseparable – is well enough chronicled elsewhere.

There was already concern about the low sales of Ordnance Survey maps to the public when, in May 1914, Sir Sydney Olivier was appointed chairman of a three-man committee set up to investigate the public availability of the Department's products. The committee concentrated on small-scale publications, by which was meant those maps smaller than the scale of 6 inches to 1 mile. Maps of 6 inches to 1 mile and above were never regarded as 'popular' or 'commercial' maps: they existed to fulfil a legislated requirement, and were aimed mainly at professional users. The advent of cycling and motoring as leisure pursuits presented an opportunity for map-makers to sell large quantities of small-scale maps, and many commer-

Making use of the Ordnance Survey's name. Important commercial map-makers such as these had come to an arrangement with OS over the promotional use of the name. Some firms were less scrupulous . . .

cial map publishers were quick to respond to the demand.

Paradoxically, the Ordnance Survey, which lent its name and basic mapping to many best-selling commercial products, failed at first to win any appreciable hold on the popular map market. Despite its reputation for producing 'the best maps in the world', the Department could only stand by in bewilderment as its rivals launched themselves into the country's bookstalls and bookshops and made handsome profits. These profits were sometimes made dishonestly at the Ordnance Survey's expense: it was not uncommon for back-street entrepreneurs to label their products 'Ordnance Survey map' or 'Based upon the latest Ordnance Surveys' or 'From the original Ordnance Survey' when their maps were nothing of the sort. Hence the paradox: the Ordnance Survey could not sell its own maps while commercial firms were selling maps on the strength of their being 'based' on Ordnance Survey originals!

In some parts of the country 'private' maps were referred to as 'Ordnance' maps even when such privately printed works were little more than crudely pirated versions of Ordnance Survey publications. In Edinburgh, where John Bartholomew's maps sold more readily than the Ordnance Survey's, some Bartholomew publications were referred to as 'the Ordnance map'.

The irony is further compounded by the fact that while the Ordnance Survey was complaining about the low sales of its maps, Bartholomew had brought in an extra eleven printing presses to cope with the demand for their publications. The Edinburgh firm was producing 60,000 cycling maps in one print run, and 225,000 copies of a railway timetable map in another!

In the case of Bartholomew and George Philip, clear arrangements had been made with the Ordnance Survey over the use of the Department's name, but such refinements were lost on many other commercial firms.*

Brutally crude cartography, which the Ordnance Survey (or Bartholomew or George Philip) would never have sanctioned, blatantly went on sale under the Department's banner. An unsuspecting public eagerly bought it.

Matters came to a head in 1914, but there had been earlier rumblings. As far back as 1895 a committee chaired by William Hayes Fisher MP, had been set up 'to consider and report upon the arrangements . . . for the sale and distribution of Ordnance Survey maps.' Among the questions considered was the availability and quality of maps suitable for cyclists.

* The Ordnance Survey had forced a law in 1911 which prohibited the illegal use of its name and reputation on the covers of rival publications. By the 1920s that law was still being ignored by unscrupulous dealers and a long series of litigations ensued in which the Ordnance Survey strove to have the law enforced against breaches of copyright and denigration of reputation. The copyright laws which have evolved from those early days are still occasionally breached despite the risk to offenders.

The selling power of the Ordnance Survey's name (Courtesy Messrs Treacher, Johnston and Cruchley)

The most appropriate thing the Department could offer was a 4 miles to 1 inch map which had not been revised for half a century. There were no plans to enter into the 'cheap map market' or to introduce scales not already authorised by the government, however useful to the tourist a new generation of map scales and styles might have been.* (There was the One-inch map, but at that time it was quite unsuitable as a tourist or cycling map: its military origins were still too evident.)

The impression left by the Fisher Committee's findings was that the Ordnance Survey maps were not really very good for anything except marching armies and town planners. (The enormous scales of 5 feet and 10 feet to 1 mile were then still in production).

By the time of the Olivier Committee in 1914, Ordnance Survey maps, although they had not changed a great deal cartographically, were being called 'the best maps in the world.' New causes had to be found to blame for the lack of sales to the public. The targets this time were the map agents and shopkeepers.

A number of factors besides that of plagiarism inhibited the sale of Ordnance Survey maps in those pre-1914 days. Discounts and sale-or-return offers being made by commercial publishers could not be matched because of the Department's bureaucratic stringency and occasional parsimony. Although the Department enjoyed a seemingly bottomless purse in the pursuit of cartographic excellence, such government generosity ended when the draughtsman laid down his pen and when the printed map – over which such fastidious skill and time had been spent – went into store. In the wake of a state-subsidised mandate, so long as the Ordnance Survey produced 'the best maps in the world' it had hardly seemed relevant whether any were actually sold.

Furthermore, the Ordnance Survey at the time was simply not geared to meet the aggressive onslaught of commercial advertising. Advertising, where it existed at all, was stolid, uninviting and even slightly threatening, *vide* the 'Rules for ordering Ordnance Survey Maps' pasted inside map covers or issued as leaflets and carried by contemporary retailers.

There were other fundamental drawbacks. In the cartographic and stylistic contents of the maps themselves, the public favoured the 'look' of the Bartholomew product. The existence of at least five different versions of the Ordnance Survey One-inch map at any one time also confused and deterred would-be customers. In the labyrinth of the Ordnance Survey's complicated map catalogues, the public lost its way.

Serving on the Olivier Committee was the Ordnance Survey's Director General of the day, Sir Charles Close. He had long felt the need for radical change in his Department's approach to marketing, and as the committee's

*See footnote on page *21*.

investigations into the poor sales of small-scale maps probed deeper and deeper, Close sharpened his knife in readiness for the interrogation of his sales representatives and agents. In a sometimes acrimonious exchange with the Fisher Unwin representatives (the Department's whole-sale agent in England),** Close seemed unwilling to accept that the

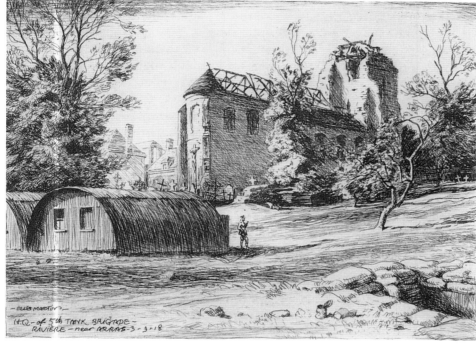

Etching by Ellis Martin: Arras, in France, was the HQ of the 5th Tank Brigade and was the scene of a battle in World War 1

* Fisher questioned E G Wheeler, agent to the Duke of Northumberland, about the higher map sales among commercial publishers. 'I suppose' Fisher asked Wheeler, 'that in some respects they [the maps] are more attractive to the general public [when] placed in covers and with other little adjustments to please the taste of the public?'
'Yes' replied Wheeler 'They are made to sell.'

** Before 1866 Ordnance Survey maps were sold through a network of 157 agents who drew their supplies direct from Southampton. They were allowed a 25 per cent discount on maps sold, but unsold maps could not be returned.
 This system was replaced by the appointment of six publishers, four in London and one each in Edinburgh and Dublin. They were allowed a 33⅓ per cent discount, but the system failed and was replaced by the establishment of 150 agents with 25 per cent discounts, drawing supplies from depots set up in London, Edinburgh and Dublin. After twelve years of this, the depots were closed, the agencies disbanded, and all sales were handled by the Stationery Office who appointed Edward Stanford sole agent in 1886, with a 33⅓ per cent discount and all his carriage costs paid by the Crown.
 Stanford secured a ten-year contract on payment of a £600 per annum fee and on condition that he gave 25 per cent discount on map prices to retail traders. He also established a number of 'sub agents' in 1892. *Footnote continued on page 22.*

Ordnance Survey might have been in any way at fault in its inability to match competition from rivals or to secure a fair share of the market. Close was barely able to conceal his lack of confidence in the agents, laying most criticism at their feet and accusing them of failing to exploit the market more fully.

Fisher Unwin argued – sometimes desperately, it seemed – that he had taken all reasonable steps to improve the sale of small-scale maps. He had drawn up newspaper advertisements, shop display cards, some of them on enamel, approached the owners of bookshops, including those on railway stations, and made up sample folios of available maps – and all of this at his own expense. He had even made up special sets of leather-bound folded maps for use in the car.

But Close persisted in asking Fisher Unwin 'what steps' he had taken to improve sales, and was apparently taken aback when the harassed Fisher Unwin exposed the malpractice of copyright infringement which was costing the Ordnance Survey dearly in lost revenue.

The findings of the Committee confirmed Close's worst fears – that his Department had simply not developed the machinery to gain a foothold in the commercial world, or to win popular recognition among members of the map-buying public. It may have occurred to him, although the Committee's Report does not say so, that his Department had not hitherto even acknowledged a need for all this commercial activity.

Some Ordnance Survey maps of the time were so thoroughly packaged in protective covers that impatient customers left them unopened on retailers' shelves. Some were cased in a crimson board cover which rendered the map's title illegible in poor light. Later, the maps would be covered in white linen or in wax-coated white boards which showed finger-smudges the moment they were handled. Few of these covers have survived in pristine condition, and we can sympathise with exasperated dealers who found it impossible to sell their stock of maps because of grubby covers.

There was no attempt at artistic design on any of these covers: nothing which appealed to the eye of the purchaser. Utilitarian in format and appearance, they carried the name 'Ordnance Survey', the map's location,

Opposite: The six basic covers of pre-1919 Ordnance Survey maps. *'If the maps themselves were masterpieces of the cartographer's art, the dowdy covers did everything to conceal the fact . . .'*

Following the Fisher Committee recommendations in 1897, the Ordnance Survey took control of its own sales, and set up a facility for purchasing maps through selected head post offices at an extra cost of 3d on the cover price (1d commission to the post office, 1d poundage on money orders, and 1d postage to Southampton). Once again, this system failed. Map sales reached a low in 1900 with only £16 worth sold, and peaked in 1902 at £81, but fell thereafter to £41 in 1906 when the post office scheme was abandoned.

In that same year – 1906 – Fisher Unwin was appointed wholesale agent, and so he remained until the Olivier Committee came together in 1914.

sometimes a sheet number, sometimes the Royal Arms, sometimes – if you were lucky – a location diagram.

The covers gave no indication that within them lay 'the best maps in the world.' If the maps themselves were masterpieces of the cartographer's art, the dowdy, easily-soiled covers did everything to conceal the fact.

Annual Reports of map sales made dismal reading. In all fairness the public could not be blamed if it bought more accessible products from commercial rivals who had a more perceptive view of what that public wanted.

The Olivier Committee's list of recommendations was a long one, but only two items concern us here:

1. *Advertising material should be prepared and circulated as widely as possible.*

2. *Map covers should not soil easily and should be printed with more attractive designs.*

Soon after the Recommendations of the Olivier Committee were drawn up, new, fresher advertising material began to appear in shops and stalls. The Ordnance Survey took over the marketing of its own products and a new network of outlets was established throughout the British Isles.*

If the Ordnance Survey's new posters, handbills and point-of-sale display cards of the period look primitive to us today, despite some effort to lighten their appeal, in their time they were quite revolutionary for a Department which approached its new commitment to marketing with a sense of apprehension and, perhaps, even distaste. There were people within the Department and in Government who felt that the Ordnance Survey's job was to make maps; selling them was hardly thought to be an Ordnance Survey task.

For these stubborn individuals, and unhappily for those shop-keepers trying to sell maps, an assassination at Sarajevo created an abrupt diversion from the Ordnance Survey's marketing problems. Before the new advertising campaigns had any real chance to take effect, the Department's military *alter ego* began to serve the cartographic needs of World War 1. Part of its staff was transferred to active service overseas while the remainder who stayed at Southampton were turned over to the massive production of 'war' maps.

* The Ordnance Survey still operated as a government unit within Ireland. That country was not to break politically with Great Britain until 1922 when two autonomous Ordnance Surveys were set up, one in Dublin and the other in Belfast, each independent of the other and both independent of the Ordnance Survey of Great Britain. Thereafter, both these Irish 'Surveys' became responsible for producing and marketing their own maps; but at the time of the Olivier Committee, all maps of the British Isles were packaged and marketed from Southampton.

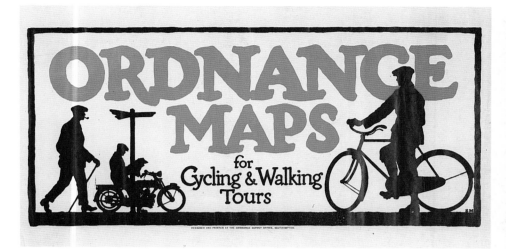

Early window sticker designed by Ellis Martin. Above: Sir Charles Close, Director General of the Ordnance Survey, 1911–22. Known as 'Daddy' to his staff, Close's appointment of Ellis Martin revolutionised the public's perception of the OS

Among the many who served overseas in the First World War, there was a young man called Ellis Martin. His artistic abilities had already attracted the attention of his commanding officer who advised the young artist that, when the war ended, he should apply for a job with the Ordnance Survey. Martin at this time was engaged in drawing sketch maps of marshy ground to aid heavy artillery moving through battle zones. When the war ended, Martin did indeed join the map-making Department and it was he, more than any other single individual, who was to change the public image of the Ordnance Survey. His impact upon Ordnance Survey map sales was immediate. In the Director General's Annual Report of March 1921, which covered the first year after Martin's arrival, Sir Charles Close commented: '*It is satisfactory to record a considerable increase in the sales of Ordnance Survey maps over any previous year in the history of the Survey. The proverb that good wine requires no bush is not applicable to the sale of maps, which requires the stimulus of artistically designed covers and advertisements. Most of these designs are due to Mr. Ellis Martin . . .*'

Martin's tenure with the Ordnance Survey started as one world war ended - and finished as another began. Within those twenty years he created a map cover style for the Department's products which was innovative and revolutionary, accomplished and distinguished, flamboyant and refined. Ellis Martin's work spawned a plethora of imitators among rival map publishers, not one of which was ever to surpass his remarkable achievements in design and execution. The bleak picture of Ordnance Survey marketing in the period before the Great War was forgotten, and the Department now dominated the market.

THE EARLY ARTISTS

Ellis Martin was not the only artist to have been engaged by the Ordnance Survey. He was, however, the only full-time, professionally trained artist to be engaged solely for the purposes of providing promotion material and map cover designs. In time to come a number of other professional artists would lend their services to Ordnance Survey map cover art, but they worked as freelances, or provided work through the Central Office of Information and other agencies.

By and large the artists engaged by the Department were recruited from among its own staff. One of them, J.C.T. Willis, was even to become a Director General in due course. These artists took time off from official duties to produce artwork for the new range of tourist, district and other maps. Their gifts ranged from the ordinary to the very good, but even those with exceptional artistic talents were capable of severe lapses. It is not always fair to blame the artists for unsatisfactory map covers, because in a number of cases inferior designs were authorised by selection panels when far better alternatives were available.

Chief among the amateur artists was Arthur Palmer, a contemporary of Ellis Martin and, for a time, Martin's assistant. Palmer had joined the Department in June 1891 at the age of 16, and for most of his career was employed in what was then called the Photo-writing section (later Photo Drawing) and subsequently in the Publications Division. He stayed with the Ordnance Survey until he was 60, retiring on the last day of December 1935. He therefore joined the Ordnance Survey 28 years before Ellis Martin arrived, and left 4 years before Martin's departure.

No records survive to tell us in what way, exactly, he was 'assistant' to Martin. But it seems likely that, as well as producing cover art in his own right, Palmer would have helped Martin with the less demanding work of cover art production, such as pasting up, location sketch maps, and liaison with the reproduction department.

Neither do we know what sort of relationship existed between the two, other than that they were 'great mates', according to one former colleague.

Opposite: Detail from Arthur Palmer's cover for the 1924 Tourist Map of *The Peak District*

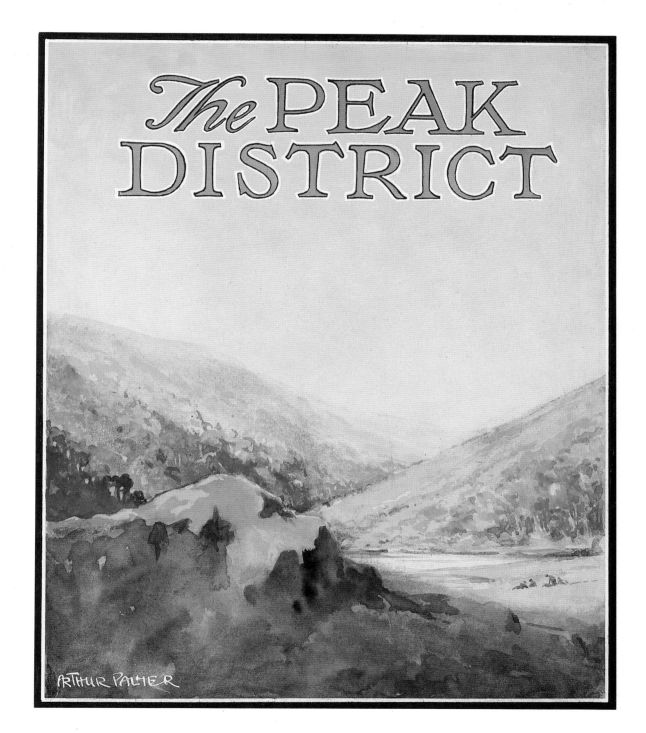

ARTHUR PALMER

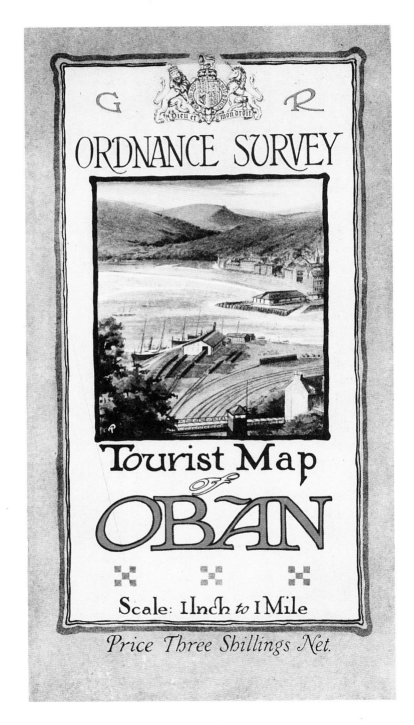

Martin was 'a quiet man who kept himself to himself, but who could get along with anyone who made the effort to get to know him'. From that, and from other eye-witness accounts, we can presume that Martin and Palmer co-existed quite amicably. We have no records of Martin's opinion of Palmer's work as a map cover artist.

How the working relationship between the two men might have operated during the time when Palmer's role was that of assistant is intriguing. Dr. Richard Oliver, author of a number of studies of the One-inch map, has traced the origins of some cover designs used on the New Popular edition of 1939 (which were not published until 1945). These non-pictorial designs were also used with different colours for a projected Quarter-inch map and a Ten-mile map. They featured an alphabet specially designed by Martin, together with a small, diagrammatic sheet location map which, according to Oliver, 'was clearly not Martin's work.' Is it in fact the work of Palmer? He was certainly not up to providing calligraphy of Martin's quality, but as a 'photo-writer', the location diagrams and general finishing designs would have been well within his range.

In order to fully appreciate Arthur Palmer's later work as a cover artist it is important to understand his early training as a photo-writer. In learning something of photo-writing we have a critical base from which to evaluate the successes and failures of his map covers.

Photo-writing, or 'Photo-drawing' as it is known today, is that stage in map production when the two separate functions of cartographic drawing and reproduction meet. The draughtsman's work is photographed to produce a negative from which the printing plate will be made. This negative is often impaired by blemishes in the form of dust specks and scratches which may have damaged names or other detail such as house-filling stipple. The Photo-writer's job is to repair all this damage: dust specks and scratches are 'blacked out' with an opague paint solution, and damaged names and detail are repaired with a fine steel point or a brush finely pointed to one or two bristles.

Photo-writing is a precise and skilled discipline. Its practitioners are required to work in subdued light, often with the aid of magnifying glasses, and they conduct their business on glass or plastic negatives. In Palmer's day, plastic negatives were unheard of, and the cold heavy glass negatives (known as 'wet plate' negatives) were exceptionally uncomfortable in winter when the photo-writer's arms – with sleeves rolled up to avoid buttons scratching the emulsion from the plate's surface – had to rest across the glass for most of the day. Few staff members relished a tour of duty in this dimly-lit office, and there were those who felt that, to be posted there, one must have 'done something pretty bad'!

Opposite: *Art-nouveau* design and limpid calligraphy – the hallmarks of Arthur Palmer's most popular cover art

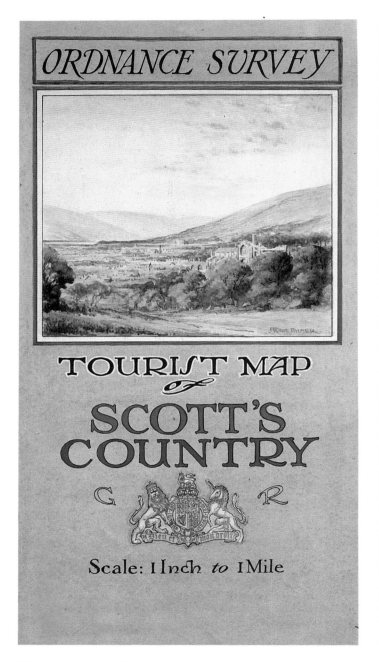

ORDNANCE SURVEY

TOURIST MAP

of

SCOTT'S COUNTRY

G R

Scale: 1 Inch *to* 1 Mile

1921 cover by Arthur Palmer

Artistic *faux-pas* and magenta: Palmer's cover design for *Lower Strath Spey*, 1921

30

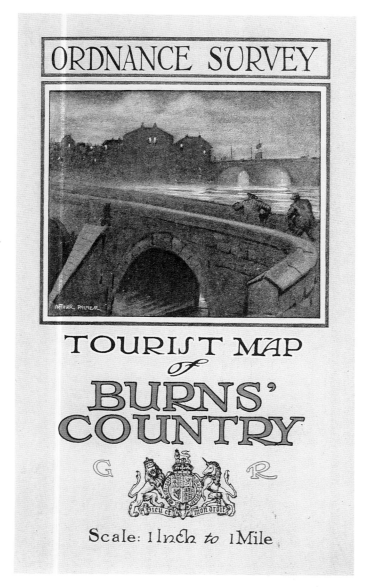

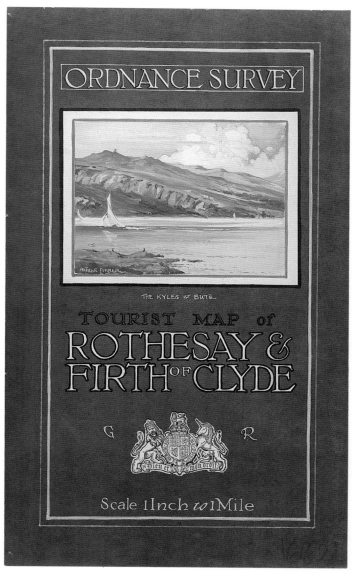

Left: Ayr's Auld Brig, painted in Palmer's melancholy style in 1921, and
Right: Although described as *Rothesay and Firth of Clyde*, some covers
of this map were titled *Dunoon and the Clyde*

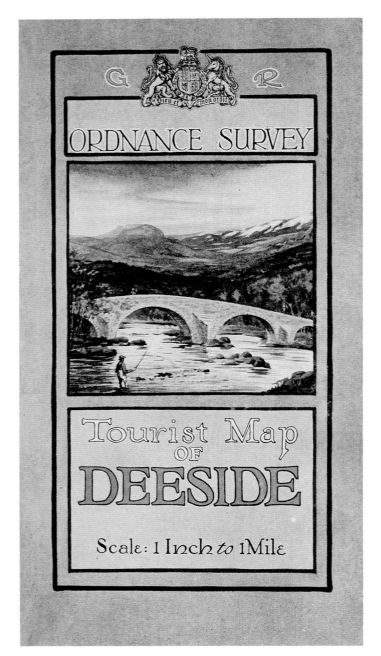

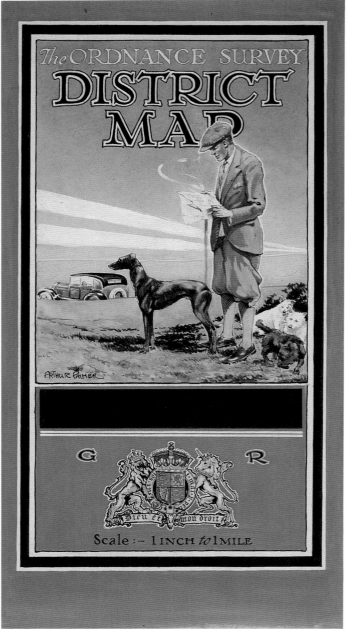

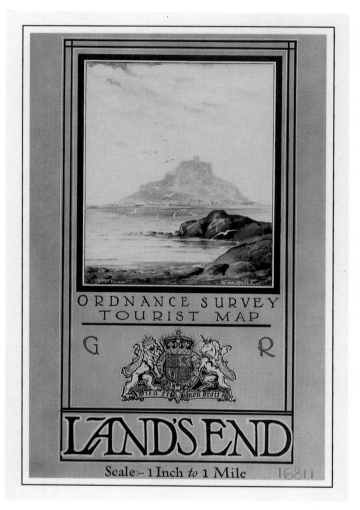

Opposite: Bridge of Dee, painted by Palmer for the 1920 Tourist Map, and Palmer's unused cover design for the District Map series. Palmer painted this in 1922 but replaced it with the black car in profile shown left. Above: Palmer's 1922 cover for *Land's End*, with St Michael's Mount in the distance

One of the skills required of the photo-writer was the ability to write a copperplate alphabet backwards* and so anonymously as to be indistinguishable from any other lettering on the printed map. Astonishingly, there were draughtsmen who could write a word or a name on a negative which would satisfy this requirement for anonymity and which could still be identified by experienced colleagues as their handiwork.

It was in this environment that Arthur Palmer spent much of his Ordnance Survey career. The fastidiousness of the photo-writer's craft both aided and marred his work as a map cover artist. At its best his artwork was very fine indeed; but his tendency to 'dabble' frequently brought him close to spoiling his pictures. On one or two occasions, published designs were certainly impaired by too much attention to unimportant details and by an undeveloped technical knowledge of his raw materials – his inks and colours.

Close put Palmer and a number of other artists to work almost immediately although, as things turned out, map cover art did not appear until 1920, by which time the war was over, the Tourist map programme was under way and Ellis Martin had been installed as Chief Designer, producing his own work and supervising that of his subordinates, Palmer among them.

Palmer's earliest cover designs were almost certainly his best, and the best of these was the 1920 cover for *Oban*, the One-inch Tourist map cover most admired by collectors of map cover art. It began his long series for the most popular Scottish tourist resorts, among which were *Scott's Country, Burns' Country, Lower Strath Spey, Rothesay, Deeside*, as well as *Oban*. He did, of course, paint pictures for some of the English series, and of these his portrayal of the Royal Liver Building for the *Liverpool District* map (unsigned, but generally accepted as Palmer's work) is the most accomplished.

The *Oban* cover was a remarkable trend-setter and made an emphatic impact. Raised on a grey board and surrounded by a freehand border, the pleasant watercolour of the resort's harbour is surmounted by the map's title. This is hand-written in a melting calligraphy which is pure *art nouveau*. The small painting of the harbour is executed in sober – almost sombre – pastel shades of brown and blue. Brown was Palmer's favourite colour; when he used it sparingly, as he did on *Oban*, he was usually

* There is a story handed down by generations of photo-writers of a group of visitors being brought into the darkened room to witness a demonstration of hand printing on negatives. One of the section's 'characters' carefully printed the word OXO on the glass plate, then sat back on his chair and declared to an admiring audience that he had just written the word backwards and upside-down!

34

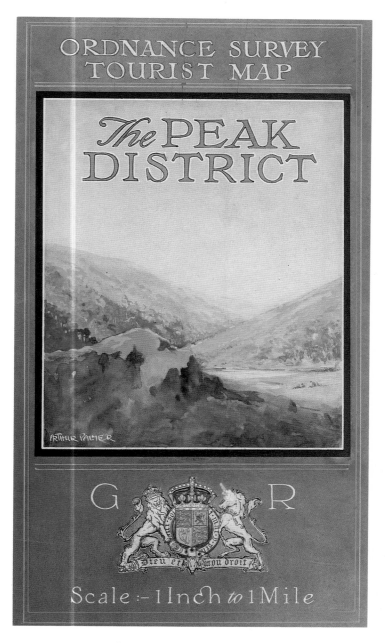

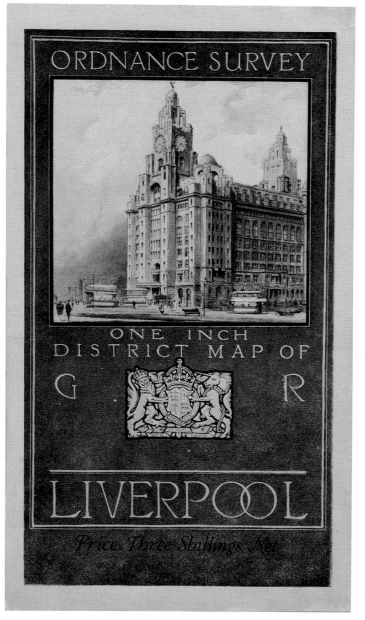

Left: Palmer's *Peak District*, 1924 and Right: the Royal Liver Building, Liverpool, Palmer's fine architectural painting for the 1924 District Map

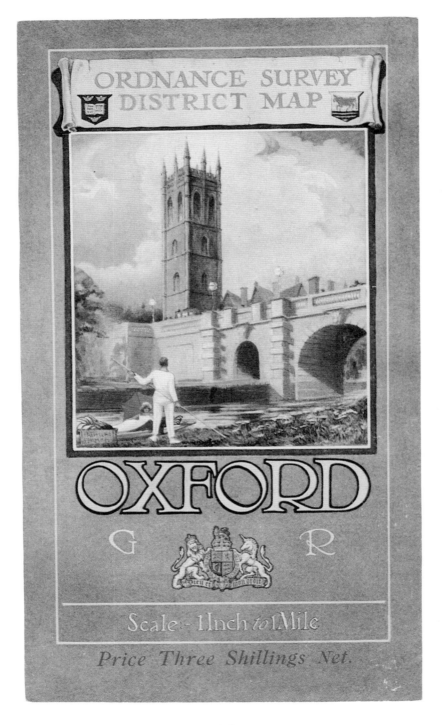

successful; but it is a colour which can easily spoil the perspective of a landscape and Palmer occasionally allowed his brush to take over and 'flatten' the picture. This over use of brown can be seen in Palmer's covers for the *Exmoor* Tourist Map. Two versions of his design survive, both ostensibly the same except for the presence in one of a scarlet-coated huntsman. This is the better-known version and, artistically, it is the more successful. This is due mainly to the presence of the scarlet figure whose tiny splash of bright colour throws the rest of the brown landscape well into the distance. Was this inspired intuition or a stroke of good luck? It was probably a little of both: intuition and chance were equally important factors in all Arthur Palmer's work. Palmer was forty-five when he painted the *Oban* cover. As an artist his tastes and inclination belonged to the Edwardian era, and his pictures are marked by an old-fashioned atmosphere which became even more anachronistic as the twentieth century advanced. Palmer's art remained frozen in an earlier age. For many admirers, this was part of its charm.

Palmer made several attempts to paint his standard cover for the District Map series. The cover he finally settled for, and which also appeared on a few Tourist maps, is one of the Ordnance Survey's oddities, but it is strikingly stylish in a naive way. Painted in almost pure colours, it shows an open tourer racing across a stylised landscape which is broken by two odd vertical bars, giving the impression that you, the viewer, are looking through a window into a strange world in which everything is surrounded by a white outline. The overall colour is crimson with the particular area name of each map in the series dropped into a panel left open by the artist.

The calligraphy for this design is bolder than that of the *Oban* map and defies the Departmental rule of the day which said that no artwork should appear above the Royal crest. In this One-inch design, which appeared in the early 1920s, the crest is in the lower third of the cover, printed in full colour, and yet it does not detract from the curious image of the passing car.

The design is far superior to a rejected version which has survived showing a walker in plus-fours standing starchily beside an equally lifeless greyhound. Had this design appeared in print, it would have been reproduced in the same eccentric colours as the published artwork.

This cover was a standard cover for the District Map series and a few Tourist maps: that is, it was used throughout the whole series of District maps for that particular specification, with each map having its own District name dropped into the open panel. Sometimes this attempt to standardise designs went awry and, when opened out, the maps were found not to be District maps at all, but something else. For example, Palmer's

Opposite: Arthur Palmer: Magdalen Bridge and Tower, 1921

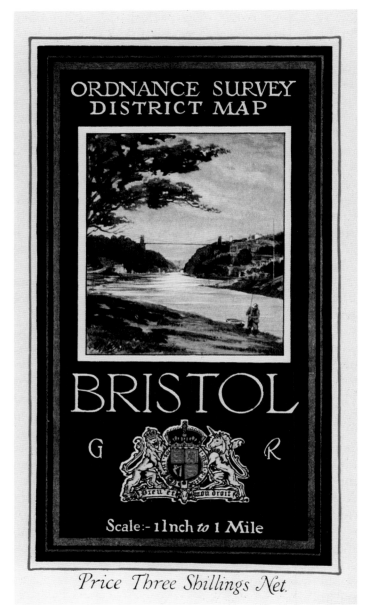

Above: One of Palmer's two designs for the _Brighton District_ Map of 1922. This one shows the Indian Memorial Gateway, Brighton. Right: No fewer than ten borders surround this striking design for the _Bristol District_ Map of 1922

'District Map' cover for Cheltenham of 1922 opens out to be a Tourist map!

Although published within the time-span of the open tourer cover described above, the *Cheltenham* 'District Map' is not of that series and occupies what is known as an 'own cover'*.

In 'own cover' maps the design incorporates a pictorial view of some scene appropriate to the area. Thus in the *Cheltenham* map we have a subdued painting of Pittville Spa executed in warm summer colours. In the gardens there is a magenta-coloured bush behind which a bonfire appears to be blazing. The logo 'Ordnance Survey District Map' is hand written in gilt and the border is formally picked out in the same colour and painted over a background of Wedgwood blue. The whole effect is quietly dignified and sedate. The Royal crest is again in the lower part of the design but this time is shown only in outline.

Palmer's *Liverpool* was the most spectacular of the District Maps. Set into a murky purple panel, the brown-painted Royal Liver Building soars upwards into a sky full of billowing pink and ochre clouds. The architectural painting is very well done: full of impressive detail and strong, effective shading. The trams and gardens at the foot of the picture are less well painted, and virtually confirm that this unsigned picture really is by Palmer. The attractive title-lettering is what one would expect from an experienced photo-writer.

Between these two splendid examples of map cover art – the *Oban* Tourist and the *Liverpool* District, Palmer produced an impressive body of work which varied considerably in quality. His *Oxford* District again shows his facility for architectural drawing; and yet the difficult lines of perspective in the *Isle of Wight* Tourist Map almost defeated him, so that his picture of Carisbrooke Castle is full of eccentric arcs and angles. It is also insipidly painted, suffering from a dominance of brown and magenta. If Palmer had ever heard of the artist's warning 'Beware magenta', he appears to have ignored it.

Palmer's poorest illustration is the design he produced for the widely-distributed *Ministry of Transport Road Map* of 1923. It is a crudely made

* A 'Standard' map series is one which covers the country, or parts of the country, to a set specification, such as the One-inch Relief map. They are cast in a predetermined set of sheetlines and are numbered sequentially. A 'District' or 'Special District' map is one in which some important location is centralised within a frame, and the map is made up by compiling extracts from standard sheets into a new, 'one-off' sheet. A 'Tourist' map is one of an area of particular tourist interest and is made up in the same way as a District or Special District map, but with new items of interest for the tourist overprinted. In Ordnance Survey practice things were not always as clearly defined as this, and it is possible to find a 'District' cover on a 'Tourist' map, just as the terms 'Edition' and 'Series' have occasionally been confused.

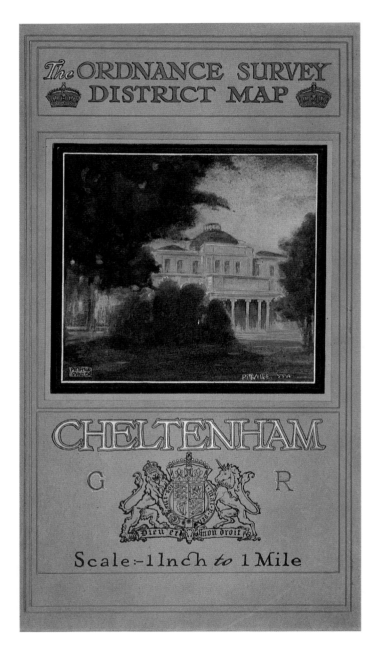

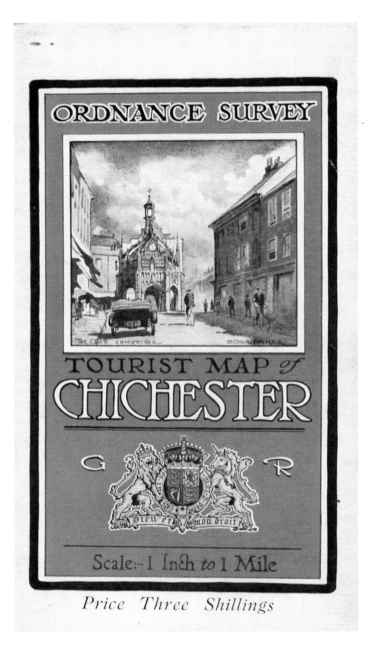

Pittville Spa, Cheltenham, by Arthur Palmer, 1922

The Cross, Chichester, by Arthur Palmer, 1922

woodcut, printed in black on a salmon-pink board, and shows two weakly drawn charabancs lumbering along a ceaselessly undulating country lane which, according to a signpost, is supposed to be the A31 to London.

This cover, more than any other, reveals Palmer's limitations as an artist, and we can only wonder at the selection board which allowed such a piece of work to go to print. It is all the more astonishing when one learns that Ellis Martin's splendid design for the same Half-inch *Transport Map*, showing the road ahead in a yellow beam of light, was rejected and never used.

Palmer committed another artistic *faux-pas* with his *Lower Strath Spey* cover of 1921 in which a fallen tree is clumsily composed and seen to be falling out of the picture's frame, thereby drawing the viewer's eye away from the focal point of the picture. The scene is again dominated by magenta and some fussy brushwork.

On the other hand, his quieter designs are very attractive, one of the most successful being his *Dartmoor* Tourist cover of 1922 in which soft, pastel colouring, stylised lettering and the background board colours all blend harmoniously.

The same lightness lifts his *Deeside* and *Land's End* covers, even if the lightness is, literally, overdone on his published version of the *Peak District*, with its blazing yellow sky. (Another Palmer *Peak District* cover, which was unused, has survived.)

All of these were accomplished paintings, despite the reservations. Examination of the original artwork reveals them to have been painted with a mixture of poster-paint and watercolour. The colour pigmentation is dry and muddy where it has been thickly applied, and only clean and translucent on the thinner washes where the pure colour can be allowed to shine out. The murkiness of some of Palmer's paintings is amost certainly due to lack of basic training: he tried to treat poster paint as though it were watercolour.

Once in a while, however, this clumsiness with the colours paradoxically paid off. His atmospheric *Burns' Country* Tourist map is unforgettable. Two hunch-backed, tam o' shantered, and very suspicious looking men peer over a grey stone bridge into a moonlit but gloomy river. In the distance there is another bridge. Almost lost in the fog, the wan lights of a group of houses across the river shine bleakly out of the shadows, adding to the melancholy atmosphere. It is a remarkable picture to find on the front of a tourist map and would certainly not be used today when bright colours (and subjects) are considered essential. Much of Palmer's art was imbued with this claustrophobic heaviness.

Palmer's Tourist Map cover for *Scott's Country*, first published in 1921,

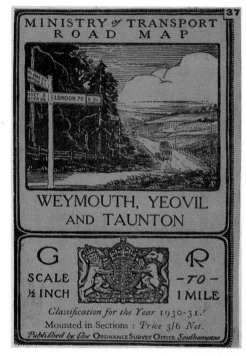

Palmer's dreary Transport Map of 1923. It was used in place of a far superior design by Ellis Martin (see page 99)

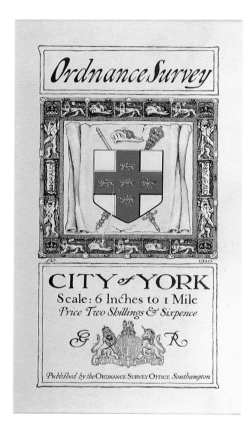

Top: The Arms of York, by Palmer. A Town Map of 1920. Above: Detail from one of Palmer's most restful designs – the Tourist Map of *Dartmoor*, 1922

is an altogether more summery affair. The detailed hachured relief map of the area around Galashiels, with the brown hypsometric tints dominating the cartography, is reflected in the pastel brown card on which the cover illustration is painted. There is a successful attempt at portraying sunshine on meadows and tree-tops, and the brown paint is used sparingly, with only a few dabs in the high open sky which gives an impression of foxing on the card. Palmer's characteristic calligraphy adds a good deal to the attractiveness of the cover.

He used virtually the same style of lettering for his Tourist Map design of *Rothesay and the Firth of Clyde*, first published in 1922 (the 1920 imprint notwithstanding!) The illustration of a group of yachts sailing in the Kyles of Bute is tiny (only 65 mm x 60 mm), but is dramatically framed in a cover of chocolate brown. The sea, hills and skies are all effectively painted, but the location name, picked out in white on the brown card, is crudely hand-written.

We tend to think of Palmer as the artist who specialised in Scotland but, as we have seen, he decorated many of the English Tourist and District Maps as well. He produced three covers for the *New Forest* Tourist Map, two published in 1920 and one drawn in the 1930s but not used. While the illustration used in the second of the 1920s designs is attractive and quite competent, the design is also simple: the title appears in a plain, red Roman alphabet, with only the Royal insignia and arms (and the price) in black. A heavy red line surrounds the card and the brown and magenta-laden picture is boxed in by a funereal black border. Nevertheless some people who live in or near the New Forest have claimed that the picture captures the essence of that great open space!

There are no less than ten borders around Palmer's District cover of *Bristol* – red, white, black, blue, black, green, brown, black, white and black! Published during the reign of George V, the map, in common with others of the time, underwent a necessary change to alter the GR to ER during Edward VIII's brief sojourn on the throne, by which time the artist had left the Ordnance Survey. Arthur Palmer had given the Department forty-four years' service and had another twelve years before him until his death in 1947 at the age of seventy-two. Despite his involvement and contribution to the public image of the Ordnance Survey in those years when it was pulling itself out of the shadows and into the market-place, Palmer is now almost completely forgotten. With sad irony he has been overshadowed to some extent by two other 'Arthur Palmers' who also contributed their talents to the Department. But neither of these namesakes has left such an important body of artistic work or had such an impact on the public face of the Ordnance Survey as 'our' Arthur Palmer.

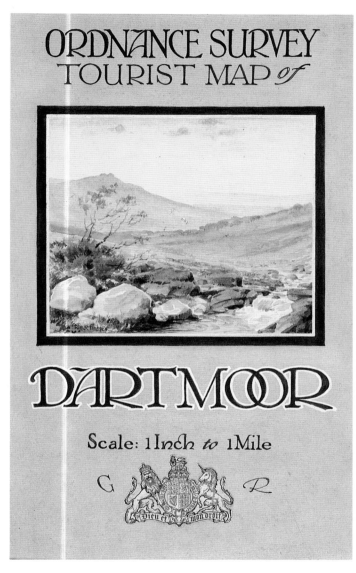

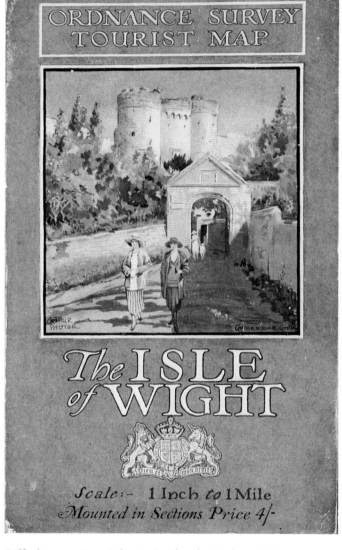

Arthur Palmer's *Dartmoor*, 1922

Difficult perspectives: Palmer's Carisbrooke Castle in 1921

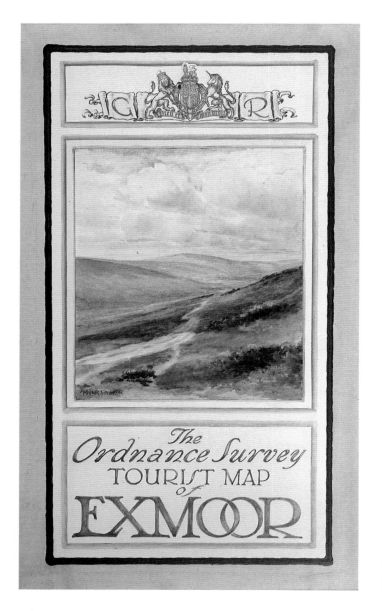

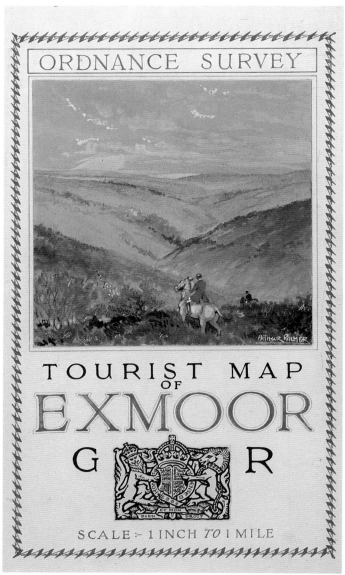

Arthur Palmer. Two aspects of *Exmoor*; one without the horseman in 1921 . . .

. . . and one with the horseman later in the same year

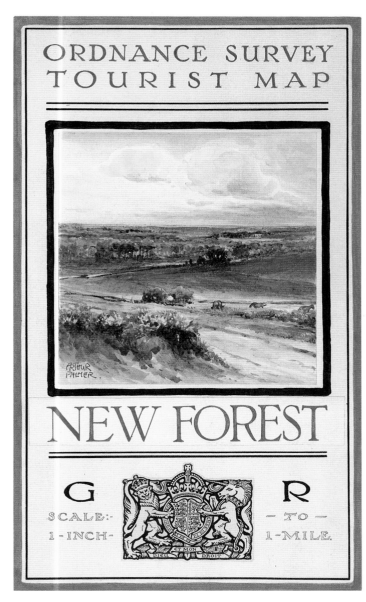

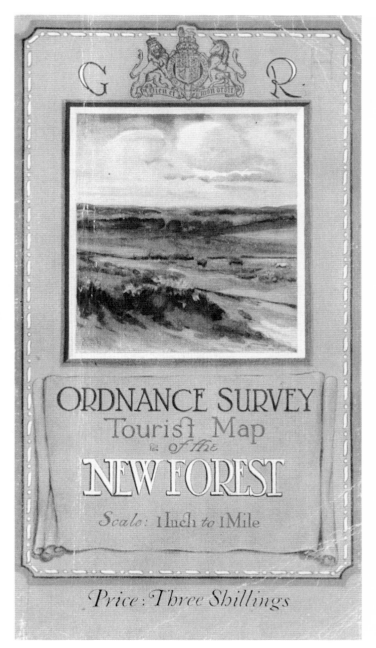

Two of Palmer's three cover designs for the *New Forest*. One was never published; these two are both from 1920.

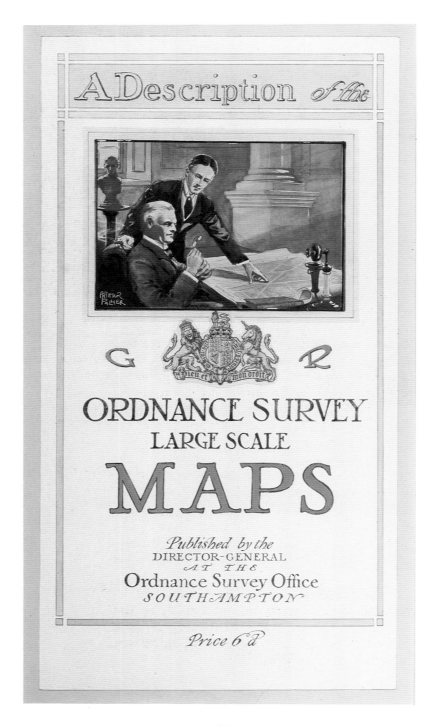

Another designer who was at work in those days was J.C.T. Willis, an able amateur artist who would, in 1953, become the Ordnance Survey's nineteenth Director General. Willis was a painter who produced full-sized pictures, some of which were reduced down to make map cover designs. He was not therefore a map cover designer in the sense that all the others were, because his paintings were not executed with map covers in mind, and only became cover illustrations because someone thought they looked suitable.

Having said that, he did provide some title lettering which was effective enough without possessing the elegance of a Martin or (as we shall see) a Hoy. The adaptation of his landscape paintings to map cover art spanned the years 1932-1936, and appeared on the covers of five Tourist and District maps: *The Peak District, Norfolk Broads, Jersey, Guernsey* and *Ilkley District*.

The paintings were bold and competent watercolours, executed in a vigorous, 'chocolate-box' style. They would be very welcome at any good local art exhibition, but they were utterly empty of atmosphere. A number of other Willis pictures have survived, beside these five map covers, and they reveal him to be an artist, like Palmer, of 'peaks and troughs' – someone who was capable of pleasing work, but who was quite prepared to see work of very poor quality going on public display.

The work which appeared on Willis's covers was in marked contrast to Palmer's designs. Gone were Palmer's murky browns and claustrophobic magentas, and in their place we now had bright, breezy landscapes with billowing clouds, painted in pure, acqueous colours. The brush-work was assured, accurate and clean, and the perspective faultless.

Willis's covers suffered from the absence of hand-drawn calligraphy. The titles are printed for the most part in letterpress, with the exception of the location names which Willis drew and which are shaded in the Ordnance Survey convention – with the light in the top-left corner throwing shadows on the eastern and southern sides of the letters. This convention is also used in the portrayal of relief on the maps themselves. The Royal crown is imprinted from a metal stamp, some examples of which are still in existence.

The gustiness of Willis's covers reflect the second 'Edwardian' age in which they were painted, although some of them did not actually appear until George VI had taken the throne. In some ways the map cover art of J.C.T. Willis, in its very absence of period 'feel', reflects the unrealistic peace of the long summer before the Second World War.

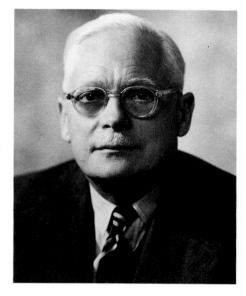

Opposite: This 'period piece' is Arthur Palmer's staid cover illustration for the Large-scales *Descriptions*. Even in these early days of map cover art, Palmer's designs were distinctly old-fashioned.

Above: J C T Willis, Director General of the Ordnance Survey 1953–7, and an able watercolour artist whose work adorned five Tourist and District maps

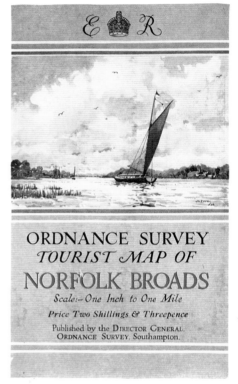

Willis: Three watercolours which were used for map covers in the 1930s. Right: detail from his painting of Moulin Huet Bay, Guernsey, 1934.

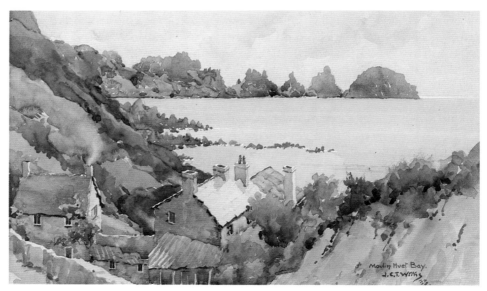

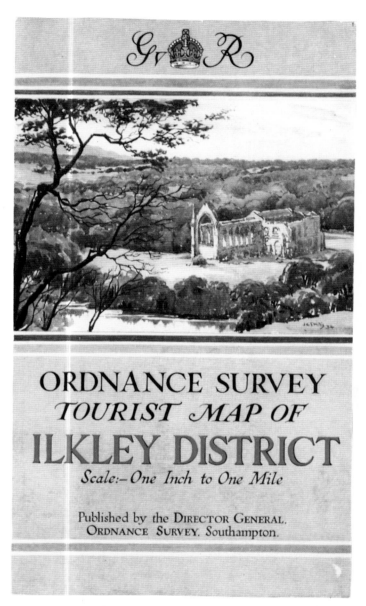

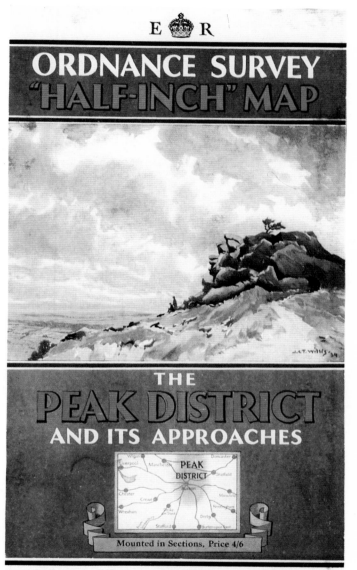

J C T Willis: designs for *Ilkley District* (1935) and *The Peak District* (1936).

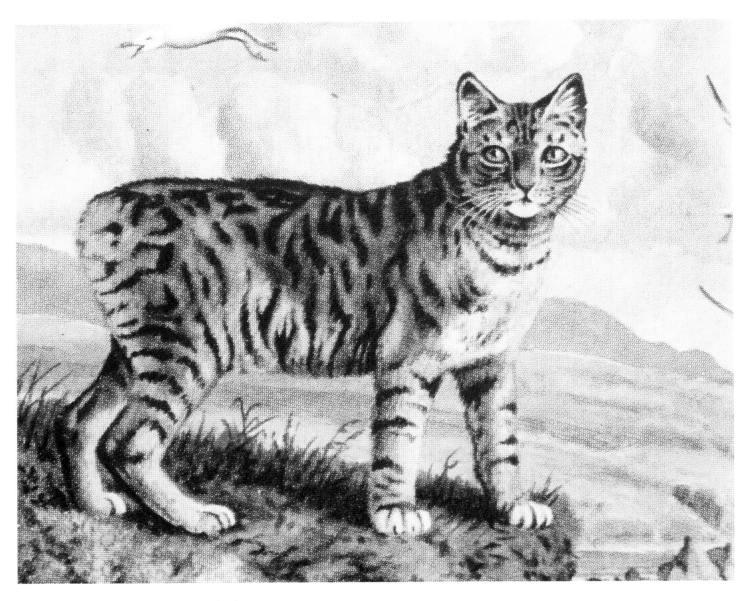

Edward John Hoy: detail from the 1921 *Isle of Man* map.

Edward John Hoy joined the Ordnance Survey in 1894 as a labourer. He became a photo-writer in 1937 and moved to the Publications Division in 1938. He retired officially in 1939 but was allowed to remain with the Department until 1945 so that he could complete his service which had been broken by ill health. By this time he was seventy-one and had spent fifty-one of those years as an Ordnance Survey employee.

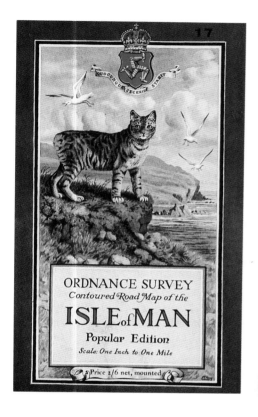

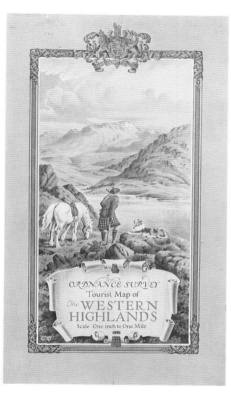

Hoy's idiosyncratic painting was seen on only one map cover – the *Isle of Man* 'Contoured Road Map' of 1921 (left). His only other cover design, *The Western Highlands*, was never published.

His output as a map cover artist was minimal: one cover published and one brought to proof stage but not used. In the Ordnance Survey's day-to-day workings, a map may be designed for a specific purpose – perhaps following market research into a likely, commercially-viable product – and its cover commissioned. At the last moment decisions may have to be taken to shelve or 'freeze' the map for whatever reasons. In time to come the map may be resurrected and published, or it may be abandoned and never see the light of day. Such a fate appears to have befallen one of Hoy's two map designs.

Hoy was an exceptionally gifted artist. He painted meticulously and with a draughtsman's fastidiousness; his calligraphy was immaculate and his sense of proportion difficult to fault. But his use of colour and his pictorial imagery were remarkably curious. He painted the cover for the Popular Edition Contoured Road Map of the *Isle of Man* and in doing so produced his best piece of work. But even this handsome cover is not without its oddities. Although painted with extreme attention to detail - and anatomically very sound – the tail-less Manx cat which stares out of the picture

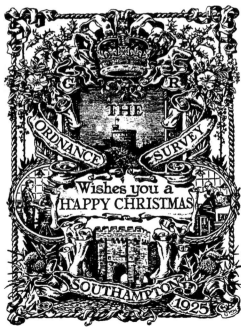

Not knowing when to stop: Hoy's congested drawings for Christmas cards.

at you is poised uncomfortably on a cliff edge brimming with purple heather and mauve boulders. The cat looks alert and is finely sculpted in excellent watercolour, but the seagulls which wheel around it are stylistically painted. Picking the map out of a bundle, there is a slight sense of shock at finding such a strange picture on a map from the Ordnance Survey. The Crown, surmounting the Arms of Man (the legs of Manannan MacLir, the Celtic 'Neptune', running on the sea) intrude into the picture in a way which Palmer's coats of arms or Martin's elaborate crests never did. Nevertheless, the cover is a striking one, and shows us that Hoy was an artist of great ability.

His unpublished cover for the Tourist Map of *The Western Highlands* (a 'map that never was') is again full of the artist's quirks. Again it is beautifully painted and shows us Hoy's highly developed draughtsmanship and his impeccable calligraphy. The torn scroll panel of the title is flawlessly drawn and moulded; the border is painted realistically to look like a real gilt picture frame, complete with embossings; and the Royal arms are painted to resemble an elaborate piece of gilt origami pulled together from the ends of the frame. All of this is quite remarkable and is evidence enough of Hoy's unique place among the Ordnance Survey cover artists.

Hoy did little else in the way of map cover designs. His work appeared from time to time in the form of Christmas cards and in the occasional special artistic commission such as the elaborate Publications Division pictogram which shows us how artistically crude he could sometimes be. His greetings cards were crammed to suffocation with detail – all of it well enough drawn – which suggested that he simply did not know when to stop. Hoy's Christmas card art may be seen in his designs for 1924 and 1925. In the 1924 card, two figures – one civilian, the other a soldier - shake hands across a landscape which is littered with the paraphernalia of survey work. The picture is rather like one of those children's 'mystery' drawings in which various items are hidden or disguised among trees and rocks. In Hoy's card are a surveyor's staff, a chain, a spade, a notebook, a pencil and a tape. There may be other things tucked away, awaiting discovery by the eagle-eyed.

His 1925 offering was even more densely packed with flying banners and scrolls, floral ornamentation, and a pictorial representation of the Southampton and Tower of London Ordnance Survey associations. The balance of the greeting's text is clumsy although, of course, the lettering itself is beautifully executed. By comparison, R.O.Richards' card for the following year was simplicity itself and represented a refreshing change. Unhappily Richards appears not to have designed map covers.

R.A. 'Reg' Jerrard produced three covers for the Ordnance Survey's

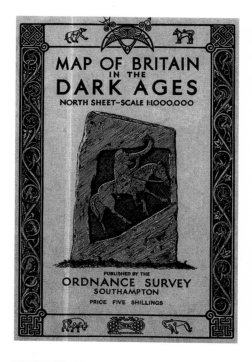

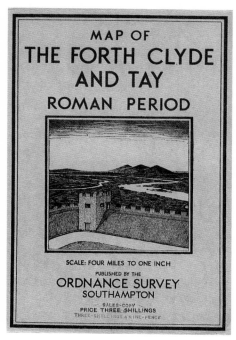

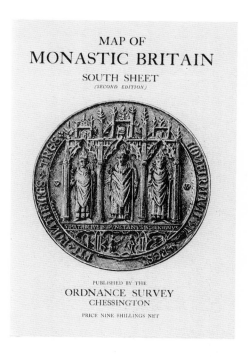

Top: R A Jerrard's three Archaeology map covers. *The Forth, Clyde and Tay* stock was mostly destroyed in the blitz and is a rare collector's piece. Above: Chocolate-box Christmas card from R O Richards.

archaeological series: *Britain in the Dark Ages (North Sheet), The Forth, Clyde and Tay (Roman Period)* and *Monastic Britain*. The series appeared in sober brown paper or card covers with titles in a severe, formal face, and were intended for publication in 1938, 1940* and 1950 respectively**.

* *The Forth, Clyde and Tay* Roman map was never formally published by the Ordnance Survey. O.G.S.Crawford, the Department's professional Archaeology Officer, anxious (as he had every reason to be) for the safety of his maps, had sent about 50 copies of this sheet to a number of friends and libraries as a safeguard against possible bomb damage. The rest of his stock was destroyed in the German air raids which struck the Ordnance Survey on the night of November 30 – December 1, 1940, just as Crawford's library was about to be moved to a safe home. Crawford's life's work was virtually wiped out in this attack and he lost all heart for any further Ordnance Survey work.

Now and again, a copy of *The Forth, Clyde and Tay*, one of the Ordnance Survey's scarcest maps, will turn up at auctions or in second-hand book shops – a rare treat for collectors.

** These maps were three in a list of over thirty 'archaeological and historical maps' which began with the facsimile printing of the Bodleian Library's *Ancient Map of Britain* which the Ordnance Survey published in 1870. More accurately, the Ordnance Survey had, in 1860, tried out its new photozincographic copying process by publishing twenty-eight so-called facsimiles of maps of the escheated counties of Ulster of 1609–10. The Director General of the day, Col Sir Henry James – who claimed, quite inaccurately, to have invented photozincography, and who liked to put his name or monogram on everything in which he was involved – actually signed a certificate on each plate declaring the maps were facsimiles, when they were nothing of the sort. They were, in fact, carefully redrawn copies of the original escheated county maps, but with a sufficient number of imperfections to betray their claim to authenticity.

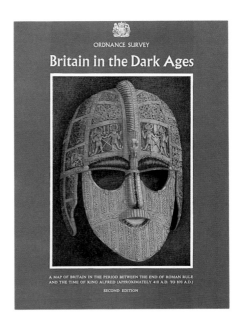

Tom Chester's striking design for the later *Britain in the Dark Ages*. Acknowledged as an excellent piece of watercolour painting, this reconstruction of the Sutton Hoo helmet was severely criticised by archaeologists when the map appeared in 1966.

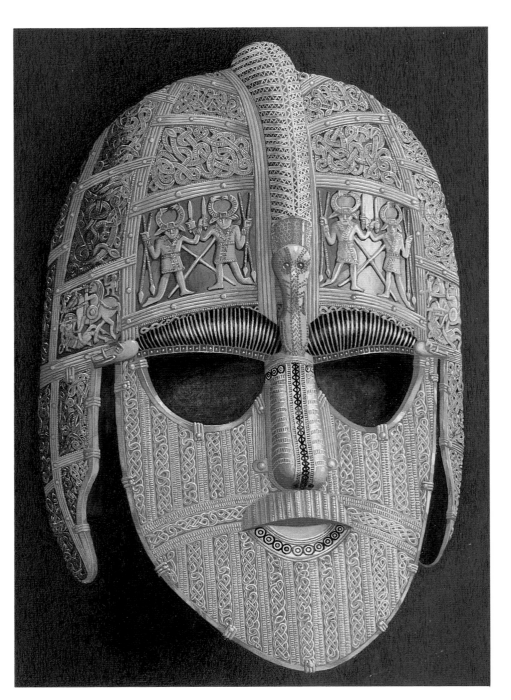

Reg Jerrard was a fastidious man whose last years with the Ordnance Survey saw him employed in the Department's Investigation Section – an area which carried out tests into new products and production methods. Jerrard was also scientifically-minded and creative, and invented a number of instruments for the new scribing process which began to replace drawing (just as drawing had once replaced engraving) in the 1960s. He was allowed to obtain a special government contract to produce his instruments industrially – an unusual official recognition of his abilities in this field.

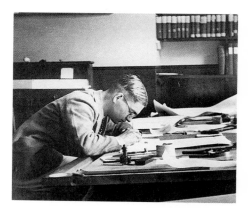

R A Jerrard at work on the cover of the 1938 *Dark Ages* map.

In 1936 he joined the infant Archaeology Division which had been established by O.G.S. Crawford. Jerrard knew little about archaeology at the time, but Crawford was a likeable and persuasive man, and Jerrard and his few colleagues soon developed sufficient expertise to work on the specialised cartographic overprints which Crawford was producing for his series of 'period' maps. Some of Crawford's small team even managed to become quite adept at some aspects of field-work.

Jerrard's three cover designs are pen and ink drawings and are, as one would expect, finely detailed. The *Monastic* cover is the most impressive, with its seal of Glastonbury Abbey portraying St. Patrick, St. Dunstan and St. Benignus. Everyone involved in the production of the map is named, except those who were members of Ordnance Survey staff. And, although the person who suggested the use of the Glastonbury seal is named in the acknowledgements, Jerrard (who actually drew the cover drawing) is not. The Ordnance Survey was insisting on that curious anonymity which has characterised its attitude ever since it took the engraver's name off its maps in the 1920s. In so doing it has created problems for later researchers trying to identify individual contributions to the Department's products.

Luckily Crawford had a more lenient attitude towards staff credits, and Jerrard's initials can be found buried away in the detail of his covers. The names of other archaeological map cover artists, if they are also inscribed somewhere in their cover designs, have still to reveal themselves.

In 1966 the Ordnance Survey published the second edition of *Britain in the Dark Ages*, this time as a single sheet, and this time with a cover of quite remarkable quality. It was painted in watercolour, and shows the vendel-style helmet found in the royal ship burial at Sutton Hoo, Suffolk, in 1939. This astonishing picture* was the first artistic attempt to reconstruct the helmet from the fragmentary artefact recovered from the East Anglian ship burial, and was painted by an uncredited artist at the Ordnance Survey, collaborating with the Department of British and Medieval Antiquities at the British Museum.

The artist was Arthur Thomas Chester who died barely a year after producing this masterpiece. He was only fifty-three. He had joined the

* See footnote on page 56.

Arthur Thomas Chester, a talented amateur artist whose work is mainly associated with archaeological art.

Department at the age of twenty-two and pursued an erratic career which took him to the Archaeology Branch for the last twenty years of his life. His *Dark Ages* cover is one of the great designs of the later Ordnance Survey years, distinguished – quite apart from the amount of detail – by the style and flamboyance of the artwork.

The original drawing for this cover has survived. Enormous skill was required to produce a work so finely executed and yet so completely free of mawkish over-drawing. Yet Chester was not a professional artist. He was a surveyor at the beginning of his career and ended his service with the Department as a draughtsman. He was, like Palmer, Hoy and Jerrard before him, an amateur artist. But on the strength of this one cover we can see that Chester possessed a quite unique talent. He also produced an exceptionally fine set of monochrome drawings, two of which were to replace the Jerrard drawing of *Monastic Britain*. Chester's drawing of the Stonehenge trilith provided the cover for the 1951 *Ancient Britain* map (North and South combined). This drawing was used again for the *Ancient Britain* South Sheet of 1965 and his drawing of a ruined broch was used on the North Sheet published in the same year.

Chester's work, all of it unsigned, appears on a number of other archaeological maps, and it lasted right up to the later maps of *Hadrian's Wall* and the *Antonine Wall*, the former published in 1964, the latter in 1969, soon after his death. Little of Chester's skill is evident in these two covers, apart from the fine filigreed border which he designed and which appears on both maps. The best testament to the skill of this fine artist is his superb cover for the map of the *Dark Ages*.

It is possible to think of Chester's *Dark Ages* cover as part of a renaissance in historical map cover art. Brian Hope-Taylor's spectacular full-colour painting for *Southern Britain in the Iron Age* was executed in 1960 and first published in 1962. A conglomeration of Iron Age arms – swords, spears, helmets and shields – are posed artificially in the lower half of the picture, while two enormous motifs of a bronze scabbard and a bronze scabbard plate form an architrave which is surmounted by three further motifs acting as a lintel across the two upright scabbards. The effect rather resembles the doorway to a tomb, and this effect is heightened by the presence on a block like doorstep of a roll of green parchment upon which is painted the White Horse of Uffington. The parchment looks like a mat woven from a piece of green sward.

Hope-Taylor was not an Ordnance Survey man, and so his name appears

* The publication of the *Dark Ages* map attracted considerable criticism from archaeologists who considered the portrayal of the Sutton Hoo helmet to be suspect. This had less to do with the artist's work than his technical advisers' reconstruction of the helmet, although some of the taint of criticism has, quite unjustifiably, rubbed off on Chester.

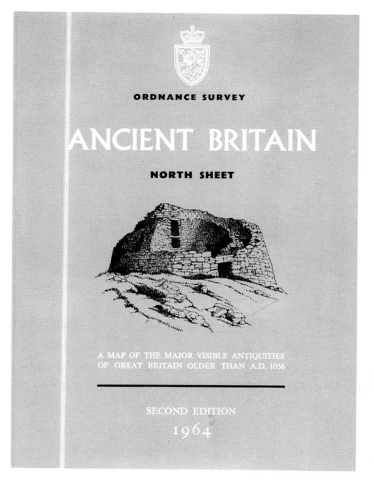

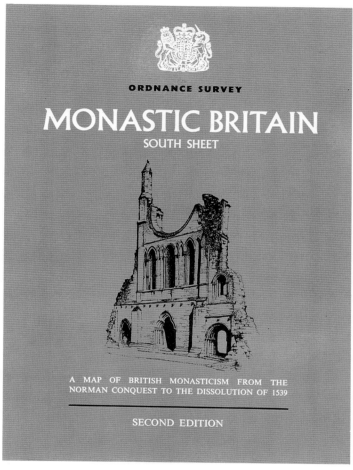

Ruins of a broch and Byland Abbey by Tom Chester, both published in 1965.

in the list of credits acknowledged by Major-General A.H. Dowson, the Director General of the day. He was, like almost every one of the thirty-four other people named in Dowson's list, a Fellow of the Society of Antiquaries. And like many other archaeologists, he was also a very able artist.

By the time Hope-Taylor painted his *Southern Britain* cover, letterpress was in full swing at the Ordnance Survey (and had been for some time) so that cover artists were no longer required to produce hand-drawn titles or ornate calligraphy. Their designs called for a panel or panels to be left open into which relevant printed matter could be dropped. In most cases this did not detract in any way from the quality of the artistic design, but in the process of 'speeding things up' some charming and idiosyncratic

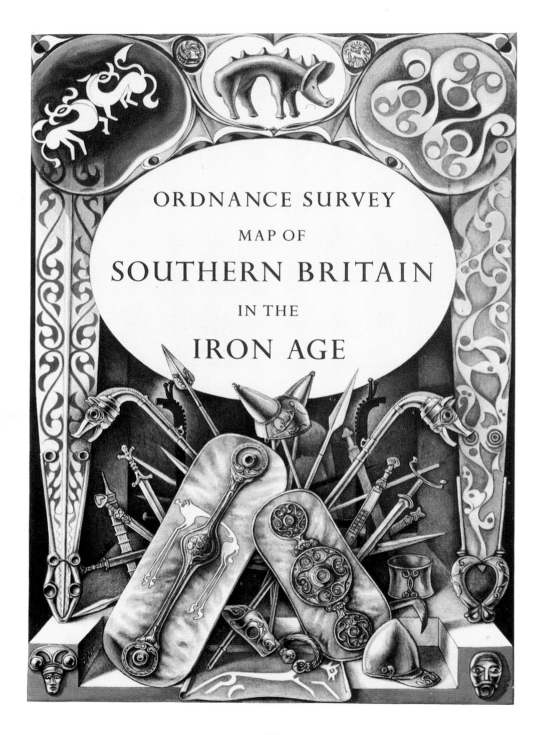

ORDNANCE SURVEY

MAP OF

SOUTHERN BRITAIN

IN THE

IRON AGE

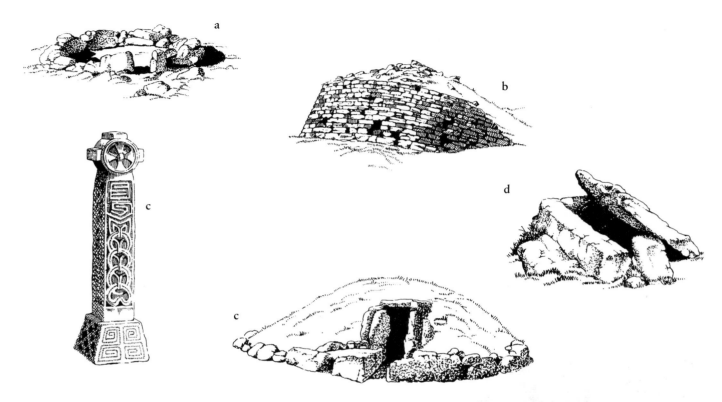

calligraphy was lost, and some rare talents were no longer stretched to their limits. Gone were the days of Palmer's *art nouveau* lettering and Hoy's impeccable alphabets: it was the end of an era. The Hope-Taylor and Chester covers may have marked a renaissance in historical map cover art – but they shone like a beacon in the gloom. Ordnance Survey art had entered the ugly design age of the late 1950s and 60s.

The unattractive era of stylised monochrome design, of bold *sans-serif* and the aptly-named *grotesque* type faces had arrived. The Ordnance Survey, always at the forefront of new trends and developments, was quick to reflect the new age. It was an age freed from old-fashioned mores. The demise of the *Roman* alphabet in art design was regarded as a break-through. The new block letters were more aggressive, punchier, more emphatic. With these new alphabets and the rise of dry transfer 'instant lettering', the Ordnance Survey entered a brief epoch of cover design which, with the benefit of hindsight, we can see to have been the nadir of a well-established craft. One day it would rise again to a new distinction when a young and talented design team would continue the tradition of Palmer, Hoy, Chester – and, of course, Ellis Martin.

Tom Chester's drawings of antiquities first appeared in the Ordnance Survey's manual for its archaeology field investigators. The drawings here are (a) the remains of a hut circle, (b) a broch, (c) an inscribed cross, (d) a cist, and (e) a chambered cairn. Opposite: 'The Trophy of Arms' designed by archaeologist Brian Hope-Taylor in 1962.

ELLIS MARTIN

THE INTER-WAR YEARS OF 1919-1939 were the great days of Ordnance Survey map cover art. This was largely as a result of the presence in Southampton of the Department's first and only resident professional artist. Other professionals have since been engaged on selected projects (such as the covers of the early Outdoor Leisure map series which will be discussed later), but Martin was employed full-time. The saviour of the Department's map cover art had his own studio within the London Road complex, was credited on nearly every piece of work he produced, and somehow even managed to be mentioned in that most formal of Ordnance Survey publications – the *Annual Report*.

Ellis Martin had been a professional artist in the years before the First World War, hired by several companies either as full-time resident artist or as a freelance engaged on specific projects. While Ellis Martin was not a full-time member of staff at W.H. Smith & Sons, the house magazine of W.H. Smith, *The Newsbasket*, mentions in 1912 that he had worked exclusively for W.H. Smith for the past six years. In those six years, W.H. Smith engaged a very active advertising agency under the management of R.P. Gossop, and several outstanding artists were employed either full-time or under contract, among them W.W. Lendon and S.E. Scott. At a higher level, the advertising agency was grouped with the printing department under its director, Sir H.E. Morgan, the first President of the Society of Industrial Artists.

Ellis Martin had designed a cover for *Advertising World* in November, 1909. This journal was a monthly publication which first saw the light of day in December 1901; it was printed and published by W.H. Smith from June 1905 and was to carry several illustrations by Martin, among which were his highly detailed advertisements for the opening of Whiteley's Furniture Galleries (21 November 1911) and Morny's (1914). Some of these advertisements also appeared in such daily national newspapers as *The Chronicle* and the original *Daily News*, both long since defunct.

The drawings executed by Martin at this time were not particularly

Ellis Martin: *The Middle Thames*, 1923. Martin's neo-Impressionist painting of Boulter's Lock near Maidenhead – arguably the most accomplished of all Ordnance Survey map cover designs.

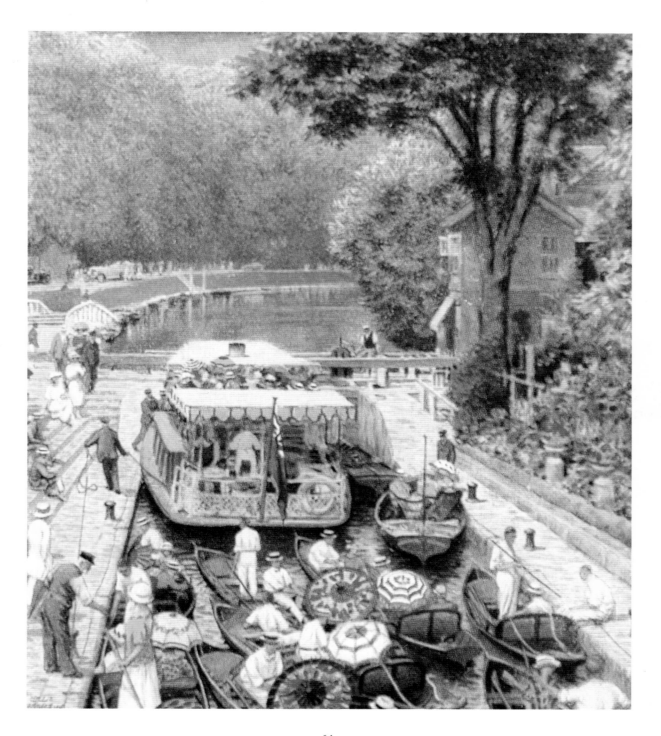

First-rate draughtsmanship: Ellis Martin's pre-Ordnance Survey designs for *Whiteley's* and the RAC (Courtesy, Whiteley and the RAC). Opposite: Martin's wife, Mabel, is a central figure in many of his most attractive designs. The handsome 'fireside' Christmas card shows Martin, the artist, in full flight. *Ivelcon* was another pre-Ordnance Survey design; and colleague C Austin Latham has provided us with this unflattering portrait of Martin in uniform.

MOTORING IN THE SOUTH of ENGLAND

Written by
CHARLES G. HARPER
with MAPS *and*
Illustrations

Burrow's "R.A.C." Guides
Issued under the auspices of the Royal Automobile Club
(Touring Department)

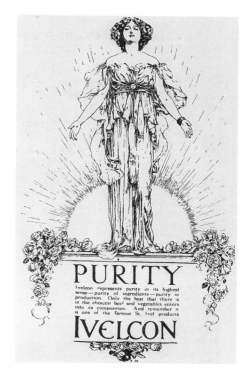

PURITY

Ivelcon represents purity in its highest
sense—purity of ingredients—purity in
production. Only the best that there is
in the choicest beef and vegetables enters
into its composition. And remember it
is one of the famous St. Ivel products

IVELCON

MARTINSKI.

individual in style, but they were the work of a highly accomplished illustrator. His striking 'Value' advertisement for the opening of Selfridge's appeared in *The Newsbasket* (1909). 'Purity' for Ivelcon (1910); and an exceptionally fine drawing of a woman (his wife, Mabel whom he had married in 1910) seated before an open fireplace also appeared in *The Newsbasket* of those early days. Between 1909 and 1914, when he departed for overseas service with the Royal Engineers, and later with the Tank Corps, he produced at least nine illustrations which can be identified in *The Newsbasket**. All of these are well executed drawings, at times dra-

* See footnote on page 65.

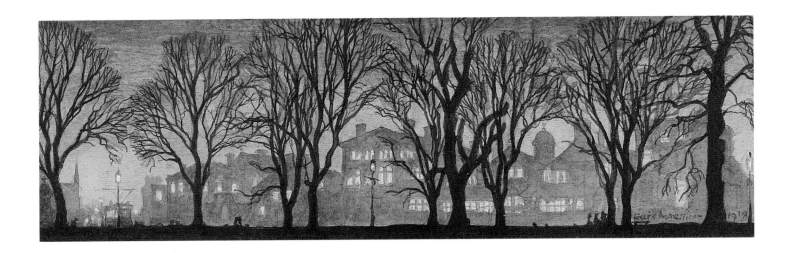

Ellis Martin's first work for the Ordnance Survey: an atmospheric Christmas card of 1918 and, below, his programme design for a 'welcome home' concert in 1919.

matically full of detail, at times delicately simple and confidently penned.

His finest and most distinctive work was yet to come.

Ellis Martin was born in Plymouth on 12 November 1881. He was educated at King's College, Wimbledon, and later studied art at the Slade where Augustus John was among his contemporaries. Although he joined the services as a sapper with the Royal Engineers, his main contribution to the war effort was as a field artist in the Tank Corps in which he sketched diagrams and maps to aid heavy artillery through inhospitable terrain. His ability as an artist came to the attention of his commanding officer who first planted in Martin's mind the idea of a career with the Ordnance Survey.

We do not know who this commanding officer was. It seems likely that he had some Ordnance Survey connection and that he was aware of the findings of the Olivier Committee of 1914. Perhaps he saw a place for Martin in the Ordnance Survey of post-war years when the Department would be on the lookout for artists as it went about the task of implementing Olivier's recommendations.

On his return to England, Martin submitted an illustration to the Department and this was used as the official Ordnance Survey Christmas card of 1918. It was to be one of Martin's most impressive works and today, more than 70 years later, it is still a familiar picture to Ordnance Survey staff. In it, we see the old London Road offices, silhouetted against a wintry sky at twilight, the lights ablaze in the windows. We view the scene through a lattice-work of leafless trees on Asylum Green, and further down London Road, a tramcar is clanging its way up towards the Avenue. Although there

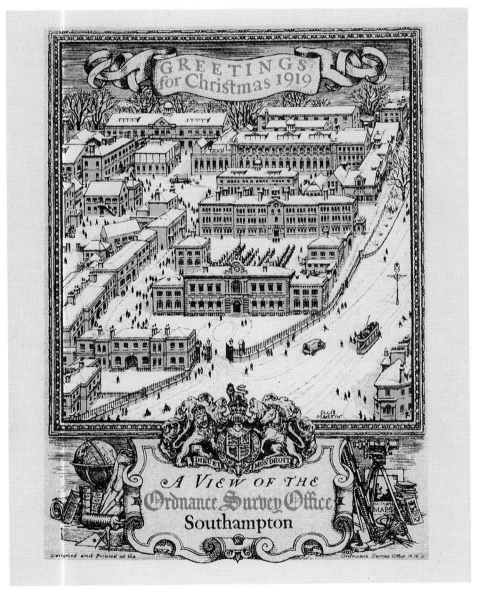

The high vantage point and the fictitious church spire: two Ellis Martin 'trademarks' make early appearances in this 1919 Christmas card. The cartouche reveals a wilful piece of Martinesque humour: behind the surveyor's level can be seen bundles of his own posters and new map covers!

* This early work carried the signatures he was to use throughout his career. Martin used three distinct signatures for his work: a handwritten 'proper' signature; a printed version with his name spelled out in full; and simply the initials EM. The handwritten signature, which he used for most of his private correspondence, appears in a number of his Ordnance Survey map covers. Occasionally, but only occasionally, it is necessary to search the illustration to find the signature. Ellis Martin not only breached the rule that 'no part of a design should appear above the Royal crest': occasionally he even put his name above the crest!

are no figures in this little painting, there is an unmistakable feeling of industry about the buildings.

As a piece of art, it has a good deal to say for itself. It is an accomplished piece of 'atmospheric' painting, with very good technique in the portrayal of light – always a strong feature of Martin's work. As a piece of observation, we have reason to be grateful to Martin for recording this particular scene, for it no longer exists.

The buildings which Martin painted in this little Christmas card had formerly been an asylum for the orphans of servicemen (hence the local name, Asylum Green) and had been occupied by the Ordnance Survey in 1842 following the fire at the Tower of London where its first offices had been located. A few additions to the buildings had been designed and built by Sir Henry James, the Director General between 1854 and 1863 who left his sculpted monogram over several doors. The picture which Martin has left us is essentially that of the Ordnance Survey's first days in Southampton. The buildings have now largely gone to make way for a modern Courts of Justice which has gracefully attempted to retain some of the flavour of the old site by using yellow bricks and black pyramidal roofs, both echoed in the surviving older buildings of the complex and in the surrounding streets.

On the right-hand side of Martin's picture we can glimpse the former Director General's house. This has been preserved as a building of exceptional interest and has been handsomely restored. It retains the Ordnance Survey connection by still being called The Director General's House.

Martin joined the Department on 9 May 1919 at the relatively advanced age of thirty-seven. His appointment (specially created for him) was 'Designer', and he was salaried at ten shillings (50p) per week, which even then was meagre and bore comparison with the earnings of an agricultural worker in the 1890s. In his first year Martin produced a second official Christmas card. The 1919 card was also to become famous and we can already see some of Martin's artistic 'trade marks' creeping into the design. This picture shows the London Road offices laid out in oblique plan formation, viewed from a fictitious vantage point on a day when snow has all but covered the landscape. We can see every building on the site: artistic licence has stretched the groups of structures apart to avoid clutter, but in other respects the portrayal is accurate. Again, a tram makes its way past the front gates, heading for Southampton town centre. Pedestrians walk past and through the gates; and in the parade ground a large body of military personnel are on morning parade. The two clocks on the South and Central Ranges point to 8.30 and civilian staff, like clusters of ants, are making their way to their various places of work.

Ellis Martin, the young artist at his desk. Opposite: Martin's illustrations appeared in many places besides map covers. The lady shading her eyes in the *Descriptions* is Mrs Martin. She appears in the selfsame pose in a number of other cover designs.

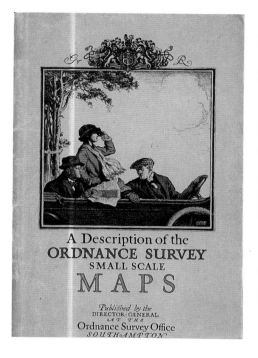

A Description of the
ORDNANCE SURVEY
SMALL SCALE
MAPS

Published by the
DIRECTOR-GENERAL
AT THE
Ordnance Survey Office
SOUTHAMPTON

A
Description
of the
Ordnance Survey
Small Scale
Maps
9th Edition

*PUBLISHED
by the Director General at the
ORDNANCE SURVEY OFFICE
SOUTHAMPTON*

Price 1/-

CARTE DU MONDE
AU MILLIONIÈME
RAPPORT DE 1927

BUREAU CENTRAL
ORDNANCE SURVEY OFFICE
SOUTHAMPTON

TOPOGRAPHY IN THE
TROPICAL FOREST BELT
BY TRAVERSE AND ANEROID

Ordnance Survey
TRAINING SERIES
No. 2.

1931

Printed by the Ordnance Survey, Southampton.

PUBLISHED BY HIS MAJESTY'S STATIONERY OFFICE.
To be purchased directly from H.M. STATIONERY OFFICE at the following addresses:
Adastral House, Kingsway, London, W.C.2 ; 120, George Street, Edinburgh ;
York Street, Manchester ; 1, St. Andrew's Crescent, Cardiff ;
15, Donegall Square West, Belfast ;
or through any Bookseller.

PRICE 2/6 NET.

ORGANIZED PLANE TABLING.

BEFORE the great war plane-tabling was responsible for large areas of topography in Canada, Africa, many of the smaller Crown Colonies, and on boundary commissions. Outside India and the near East this plane-tabling was done, exclusively, by officers and other ranks of the imperial army. Since the great war, many surveys have been made in the tropical forest belt by instrumental methods and although several boundary commissions have used the plane-table the number of topographers so engaged has been small. We have to-day few experienced plane-tablers. Meanwhile colonial surveyors are beginning (as in Uganda and the Sudan) to survey topographically and in gaining experience feel the want of a model field sheet and of a summary of the more immediately practical points of draughtsmanship which have never found expression in print. For the soldier and civilian plane-tablers of the Empire the enclosed field sheet is therefore reproduced exactly as it appeared when sent in from the field.

The plane-tabler who did this sheet was an exceptionally good craftsman. The survey in which he was engaged had, at that time, over four years of experience. The model may be accepted as one to follow.

The style of the model and the hints of the accompanying letterpress refer, however, to a systematic properly organized survey. For geographical or exploratory work they would provide an over meticulous guide. They refer, too, to that style of single man graphic plane-tabling, perfected in India, and vastly superior to instrumental method for small scales with good visibility. In forests one must needs use other means; at a scale of 3 inches to the mile and over, even in open country, the tachymetric plane-table may compete ;

5

but generally speaking for the smaller scales the graphic survey on the plane-table is supreme for accuracy and for economy. This class of plane-tabling has been used in many places of such apparent difficulty as to suggest recourse to instrumental methods. It has been, and is being, used with success in Ceylon (with its almost general forests or tall timber). In India and Burma it has done yeoman service. It was used for Jersey with its bad visibility and hedgerow trees. Even in the dull climate and low relief of Flanders it was invaluable. In the opener parts of Eastern, Central, and South Africa it is, of course, the obvious solution. It is, however, dependent for speed, accuracy and economy on the proper preliminary use of the theodolite.

There are, then, two craftsmen involved, the trig-observer and the plane-tabler. By providing a proper control the former makes it possible for the latter to use a light and simple outfit, and to employ his graphic methods within those narrow limits in which their inherent weaknesses have no room to propagate error.

Organization of the Party.

Experience seems to prove that the more open and easy the country, the larger must be the proportion of trig-observers to plane-tablers.

In open and easy country 2 trig-observers will cater for 4 plane-tablers and 1 reviser or examiner, but in army practice the trig-observers have always been the officers of the party who have also to settle policy, administration, transport and pay. In cases, then, where administration is divorced from field work, some saving on these numbers may be possible.

With so small a party details of organization are not particularly important. It is more important to have good men than good rules, but there are points of interest. For example, it is the ideal to camp plane-tablers individually and to give each one sufficient transport and service to allow of shifting camp as often as the circumstances dictate and actually whilst out at work. There are however those, temperamental as the moody dane, who cannot help introspection. These weaker

Elaborate Christmas card for 1920, the drawings and hand-lettering by Ellis Martin, the verses by Alfred Oscroft. The card was, in fact, a 12-page booklet on heavy art paper, few copies of which appear to have survived.

2 *The* Making

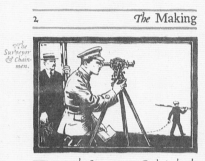

of a MAP. 3

FIRST, *the* SURVEYOR, *Book in hand,*
 Directs his Chain-men *o'er the land,*
Records each feature,—vale or hill,
The forest dense, or sparkling rill;
Whilst (to arrange his lines *aright)*
He peers through his Theodolite.

NEXT, *on the* Plot *the lines are laid:*
 A Tracing *of the whole is made;*
From this the DRAUGHTSMAN *skillfully*
Prepares the Plan,—*which soon will be*
Engraved, Reduced, *or* Photographed,
Transferred-*to*-Stone, *or* Zincographed.

6 *The* Making

of a MAP. 7

HERE, (*on a* Rotary Machine)
 The Printing *of the* MAP *is seen;*
In detail, contour, colour, name,
Worthy of ORDNANCE SURVEY *fame:*
Each feature, whether plain or tinted,
In character distinctive printed.

WITH *all due speed, by rail or road,*
 By post, by hand, by varying mode
The MAPS *are sent, to be a guide*
To men who walk, to men who ride:
Peasant and Prince here see displayed
The Country's *face, with skill portrayed.*

Beyond the Director General's house a church spire is faintly discernible. This is a Martin 'trade mark': he was fond of adding church spires to his drawings, even when none existed in reality. St. Edmund's Catholic church is in the Avenue, just beyond the Director General's house, but it has no spire except in Martin's drawing of it! The elaborate cartouche at the bottom of the card gives us another example of Martin's humour while at the same time providing evidence that the new programme of advertising Ordnance Survey maps was now in full flight. Behind a tripod and surveyor's level, there is a group of maps and posters with Martin's own designs prominently featured: he has produced drawings of his own drawings! The ornate Royal Arms was hand drawn by Martin – as it was every time it appeared on one of his covers or there was a change of monarch. Martin always subtly altered the formal design of the Arms so as to make it less obtrusive in his drawings.

Like its predecessor, the 1919 card is a remarkable historical document. It shows the state of the Department's premises at the time when they were at their best and before the German bombing raids of 1940 would change their pattern forever.

In that same year, 1919, La Carte Internationale du Monde au Millionième was formally inaugurated to produce a series of national maps, worldwide, to a standard specification and to the uniform scale of 1:1 000 000. Known colloquially as the 'IMW' (the International Map of the World), it got off to an uncertain start and has continued its erratic course down the years, with a wide variety of specification changes adding complexity for anyone who thinks that here at last is a 'standard' map of the world's nations.

The organisation did not actually come to fruition until 1921 when its first Report appeared from the Central Bureau which had been set up at the Ordnance Survey under Lt-Col Winterbotham, the flamboyant Director General from 1930 to 1934, who acted as secretary. This report carried a frontispiece or logo designed by Ellis Martin. It was in the style of Martin's early commercial art days: a globe (with the British Isles in the centre) is supported by a group of four cherub-like figures representing the nations of the earth. One wears a turban; another wears a feathered head-dress; one is white and one is black. Around the group there are billowing clouds and a waving banner proclaiming that this is the *Carte Internationale du Monde*.

Although it is a distinctive design and finely drawn, it lacks the elaborate intensity of the true cartographic cartouche, and belongs more properly to the nursery where it would not have looked out of place in a child's story book. However, the IMW committee liked the logo sufficiently to use it

for many years, and it has turned up on menus and on the personalised greeting cards of some Ordnance Survey staff, not all of them IMW officials.

Ten years after Martin had left the Ordnance Survey, his logo for the IMW *Reports* and supplements was still being used. Some recipients of the *Reports* got no further than Martin's cherubs: in a letter to Winterbothan, A.R. Hinks, long time secretary of the Royal Geographical Society, confessed 'I have admired the cover, but have not yet dipped into the *Report*'. The year before, Hinks wrote to Sir Charles Close: 'I ought to have written earlier to thank you for the excellent Christmas Card. I am glad to see that you still have Mr. Martin with you.'

The 'excellent Christmas card' was Martin's unusual offering for 1920, a witty and expensively-produced card which came in the form of a 12-page booklet, printed in two colours on heavy chart paper. This elaborate production, with seven drawings by Martin, including caricatures of office staff, shows some of the stages of map production together with the story told in droll verse. It must have cost the Department a good deal in both money and effort, and – judging from the relatively few copies of the card which have come to light in recent years – seems to have been printed in strictly limited numbers.

Martin went on to produce several more Christmas cards for the Department one of which – a lovely watercolour – depicts his favourite Ordnance Survey building, the South Range. The painting shows the offices closed up for the night, but with the yard lamps and the clock high up in the tower, alight. It is a peerless winter evening, the streets covered with snow, and yet the car which is passing by is an open tourer. Beneath a tree a man pauses to light his pipe and the match glows in his face. Was Martin showing off the range of his skills when he painted this card in 1922? All the tricks and accomplishments of the professional artist are here, right down to the greetings which are hand-printed in a midnight blue along the bottom of the card.

By contrast his card for 1923 was a stark, functional monochrome drawing which set out to please both field and office staff, for it shows a group of military and civilian surveyors at work in the field, and a busy printing machine giving off its first pulls. The two sets of drawings are separated by an enormous architectural scroll, full of bunches of grapes and tassled cords, into which is set the seasonable greetings handprinted in one of Martin's impeccable alphabets. The card is the same size as the current One-inch map of the day; and the '*Contoured Road Map*' is drawn with the same time-consuming fastidiousness.

Martin produced no further Christmas cards until 1932 when he designed a highly distinctive and original card which, when folded, measu-

Ellis Martin Christmas cards for 1922 (top) and 1932. Once again, in these pieces of ephemeral art he demonstrates his ability to produce atmospheric landscapes and impeccable calligraphy.

red only 3 inches in width, but opened out to a 6 inch panorama showing a top-hatted nineteenth-century figure riding an iron bicycle – a 'hobbyhorse', fashionable in the 1820s – and a pipe-smoking motor cyclist on a heavy contemporary machine. In the background there are walkers, cyclists and motorists as well as a seasonal stage coach. The card reminds us that 'The first Ordnance Survey Map was published on the first day of the Nineteenth Century' (assuming that the 19th century began in 1801). This attractive souvenir was to mark the last days of the great Ordnance Survey Christmas card, although cards continued to be produced regularly up to the present day.

CATALOGUE of MAPS
and other Publications of the
ORDNANCE SURVEY

1924

Published by
Colonel-Commandant E.M. Jack, C.M.G., D.S.O., R.E.,
(Director-General, Ordnance Survey)
and printed at the Ordnance Survey Office,
SOUTHAMPTON.

Catalogue Cover designed by Ellis Martin for the Ordnance Survey Office.

THE ORDNANCE SURVEY
"ONE-INCH" MAP
*The Complete Guide to
the Countryside*

ORDNANCE SURVEY OFFICE
SOUTHAMPTON

Ellis Martin: designs for a Christmas card, a
Catalogue, and a shop display card advertising
the One-inch map of the 1930s

In the meantime Martin was engaged on his series of map cover designs and advertising material – leaflets, posters, shop display cards, and drawings for specialised official publications. As he produced them, the more discerning map customers recognized their quality, and bought Ordnance Survey products in ever greater quantities. In the market place, rival companies sought to keep up with the flood of innovative and creative ideas.

Martin was given a small studio on the ground floor of the South Range, the building which he painted and drew so often. Although, as we have said, he appears to 'have kept himself to himself' his incumbency of the post was a happy time for him.

His wife Mabel (née Verstage) and daughter, Gentian (who was to die tragically early of tuberculosis in 1940) came to Southampton and set up house at 6 Highfield Close. For a while they also lived at a house called The Anchorage in the town's Hulse Road, near to the County Cricket Ground. For his own pleasure Martin painted many scenes in and around Southampton, recording aspects of a town which was soon to change beyond recognition. His little watercolour of Brunswick Place in the town centre, caught the flavour of this handsome residential street before it was redeveloped into office blocks.

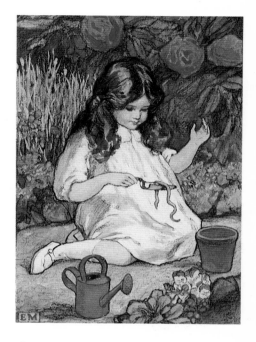

Ellis Martin's daughter, Gentian – an affectionate portrait by her father.

Martin also visited the countryside around Guildford and Dorking (his wife came from Godalming) and he produced many attractive watercolours of these areas. The formality of some of these paintings suggests that they may have been designed for use on future map covers. But while there was certainly a *Dorking and Leith Hill* map, and a Dorking painting, the two never came together.

As Martin turned up for work each morning, he would have entered the South Range by the central front doors and turned right into his studio. Above the front door of the building he would have seen the pair of fine windows which he had designed as a memorial to those Ordnance Survey staff who had lost their lives in the Great War. By a cruel irony, these windows would be destroyed, along with his studio, by enemy action in 1940. A monochrome photograph was taken of the windows soon after their completion and Martin was later able to hand-colour this photograph from memory. It is his colour reconstruction which is reproduced in this book.

Martin was a prodigious worker, moving easily between different media. He sketched with pencil as confidently as he drew with pen and ink; he painted in both watercolour and oils. None of his Ordnance Survey work was executed in oils or pencil, but his first Christmas card of 1918 was a mixture of watercolour and crayon. His family were willing models for some of his most attractive pencil drawings, and his wife, brother and

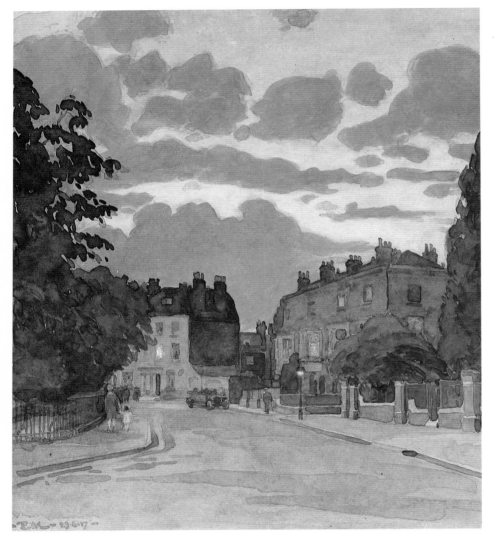

Opposite: Martin's work was put to a wide range of uses. Designs for other map covers were pasted on to maps such as *Limerick* and *Londonderry* (originally printed long before he joined the Ordnance Survey) to get rid of old stock.

Above: watercolour sketch of Brunswick Place, Southampton, and a pleasant wintry view of Dorking in 1915, both by Ellis Martin.

Above: Col C O Place of the Royal Engineers invented the waterproofing technique which bore his name, and Ellis Martin designed the 'logo' for the paper's first appearance in about 1929.

Opposite: a moment captured in paint. A cyclist and walkers on Box Hill, Surrey, pause to watch a train leaving Dorking. Ellis Martin's splendid watercolour may have been painted with a map cover in mind but, though a *Dorking* map was published, this picture has never been seen publicly.

brother-in-law were the main models for his Ordnance Survey covers. In some cases the same relative posed as driver and passenger in a cover design featuring a vehicle! On a return trip from such a modelling excursion Martin remarked that his brother Dick was 'beginning to look like a very old man, and he won't be 90 until May!'

Similar anecdotes abound about Martin. He painted a view of the lake and picnic area of Cowdray Park in the 1920s. Nearly forty years later he decided that the cars in his painting were too old-fashioned so he painted them out and replaced them with newer models.

We have already seen how, with a tongue-in-cheek humour, he painted in samples of his own published work in the Christmas card of 1919. A similar whimsy pervades his most famous map cover, that of the cyclist who sits overlooking a steep, verdant valley, studying his trusty One-inch map. When first painted in the 1920s, the central figure was dressed in Norfolk jacket, tweed cap and plus-fours. Years later, he revised the design by changing the cyclist into a hiker, taking away the cumbersome tweeds and giving him a pullover and shirt with rolled-up sleeves, and sitting him on the selfsame hill over the selfsame valley. But had not many years passed by? Martin made the trees a little taller and the vegetation a little more abundant.

There was more than a little marketing psychology in this pictorial representation of the 'outdoor type', and the marketing potential of the design was not lost on some reviewers. As recently as 1969, D. Macer Wright, a reviewer writing in *Country Life* recalled:

> He (the figure in the map cover) is unencumbered by any female, a man's man from his well-shorn head to the tips of his hiking boots, yet a man any girl would be proud to own. The epitome, in fact, of the healthy outdoor male. What male of this description could resist this map?

The two covers (original and revised) were the most widely used of all Martin's designs, occupying as they did, the Department's flagship, the One-inch map. Many who have bought the One-inch map featuring the cyclist/hiker cover have striven to identify the spot (Derbyshire, or Cornwall, or Lancashire?) which the artist used for his cover picture. In fact, the picture was used as a 'standard' cover design for the entire series of that edition of the One-inch map, with the one exception of the *Isle of Man*.

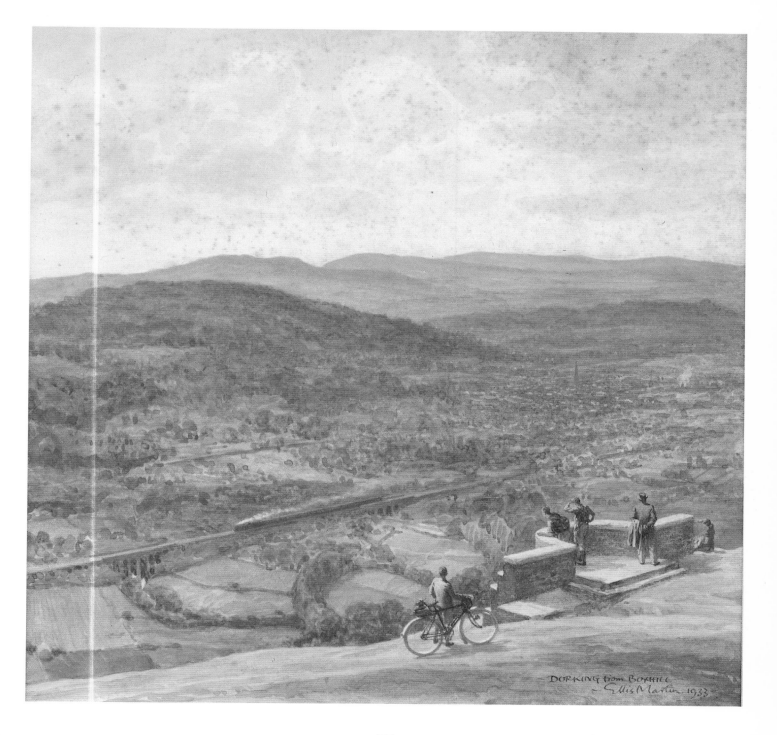

The South Range of the Ordnance Survey's former Southampton
headquarters at London Road. It appears on many Ellis Martin designs.
His studio was to the right of the front door, and the two square windows
directly above the front door were later removed to make way for the War
Memorial windows which he designed after 1918. In a sad irony, the
windows and most of the building were destroyed in the blitz of 1940.

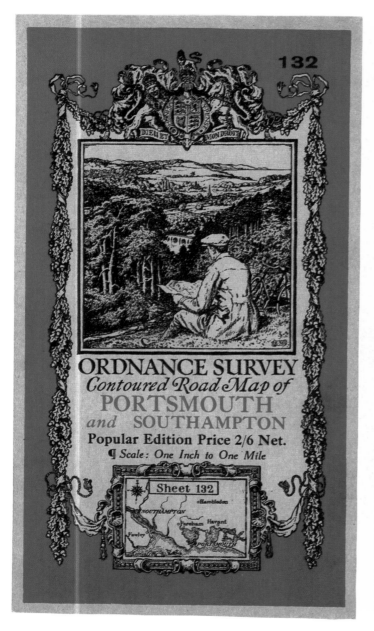

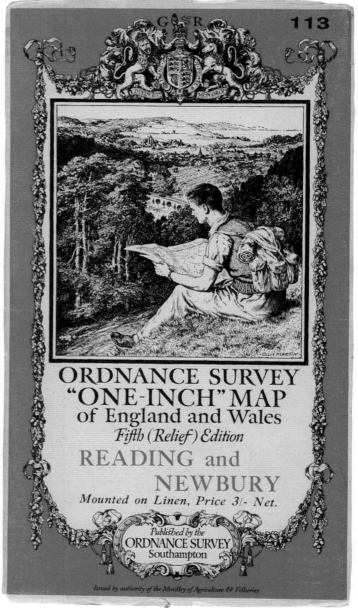

Variations on a theme: Ellis Martin's classic covers for the One-inch maps
of 1918 (left) and 1933.

ORDNANCE SURVEY
"ONE-INCH" MAP OF
THE CHILTERNS

Price Three Shillings Net
Published by the Ordnance Survey Office,
SOUTHAMPTON

The great outdoors: hikers stride out on the
Chilterns in this vigorous Ellis Martin picture
of 1932.

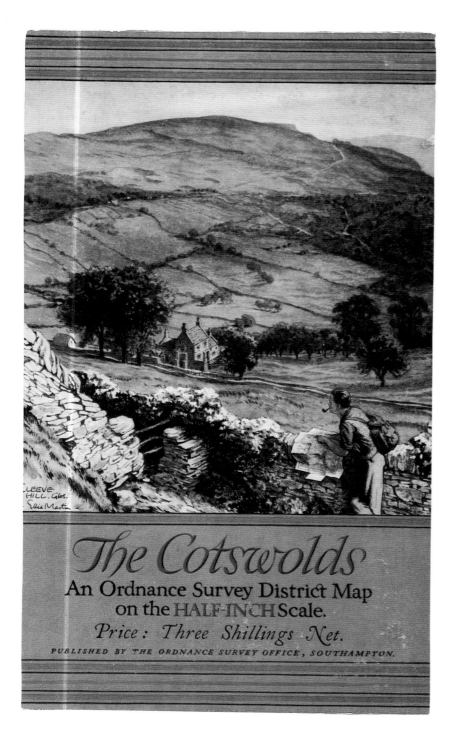

Cleeve Hill, Gloucestershire, was painted by Ellis Martin for the cover of the Half-inch District Map of 1931. As we have seen, this picture was also used to promote the One-inch map.

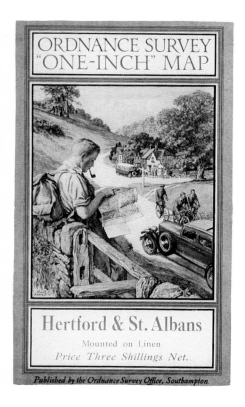

ORDNANCE SURVEY
"ONE-INCH" MAP

Hertford & St. Albans
Mounted on Linen
Price Three Shillings Net.

Published by the Ordnance Survey Office, Southampton.

Above: *The high art of map selling . . .* One of Ellis Martin's most famous cover designs; the pipe-smoking hiker appeared on Tourist, Popular and District maps throughout the 1930s.

Opposite: Mrs Ellis Martin again shields her eyes from the sun in this detail from another famous cover design.

In his classic design for the One-inch District Map cover, a pipe-smoking hiker leans against a country wall perusing his open map. On the road below what looks like a Morris Major is speeding uphill. This particular design is rightly regarded as one of the great map covers. D. Macer Wright wrote perceptively of it:

> *The picture contains six sensible people; one young hiker, three cyclists and the two locals standing outside a pub. The trippers (from the bus) are kicking it up inside. This cover represents the high art of map selling. It has four targets, walkers, cyclists, motorists and tourists en masse.*

The cover forms part of a parcel of similarly vigorous landscapes, all painted in approximately the same style, all belonging to the same period, all inviting the attention of the same groups of people – but not necessarily all of the same map series. The maps were published in the 1930s when the newfound delights of the open countryside were beginning to find favour with town dwellers and desk or factory workers. It was the age of the wide open places, of the cycling and motoring and railway crazes.

Unhappily for walkers and ramblers, the open countryside was not all that open in those days. Most tracts – even apparently wild and uninhabited areas such as the Pennines and the Lancashire moors and the Peak District – were under private ownership, and these owners were not averse to employing strong-arm tactics to keep walkers off their property. The so-called 'Mass Trespass' of 1932, organised largely by the late Tom Stephenson, led to the creation of the public rights of way across open country which we now enjoy, although not before a good many participants suffered cracked skulls at the hands of landowners' keepers. One of those who took part in the Trespass was Ewan MacColl, later to become a well known folk singer. He wrote a song for the Trespass which became the anthem of the Ramblers' Association and is still sung fifty years later:

> *I'm a rambler; I'm a rambler from Manchester way,*
> *I get all my pleasure the high moorland way;*
> *I may be a wage-slave on Monday*
> *But I am a free man on Sunday . . .*

The 1930s saw a large increase in demand for maps suitable for walkers and ramblers. The One-inch was hauled into use as Tourist and District maps and Martin designed their striking covers. Apart from the cover already discussed, there was another featuring two hikers – a man and a

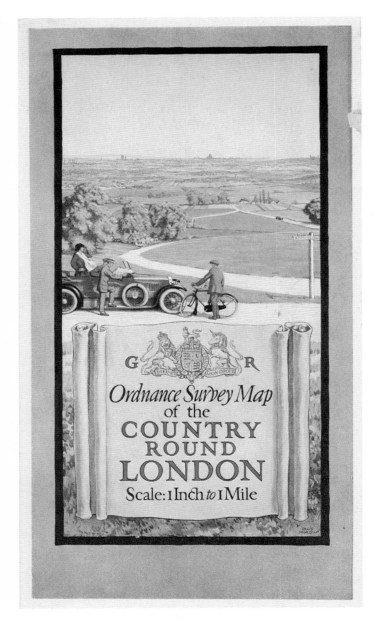

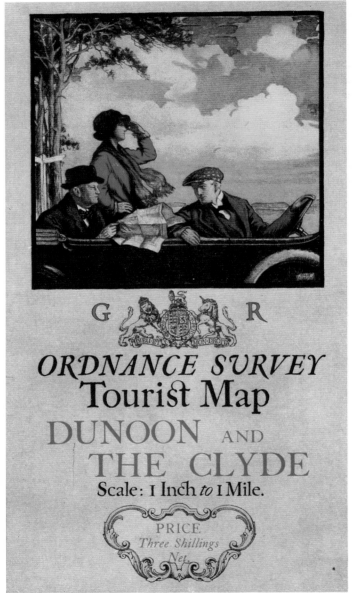

Family affairs: Ellis Martin's wife, brother and brother-in-law are the models in these characteristic cover designs.

woman – striding out along a track which winds into a hamlet in a lush valley, and then away again into sunlit hills in the far distance. This was *The Chilterns* District map. In another cover of the same time, a hiker pauses by a broken-stone wall, his map opened out over the stones while he gazes at the distant mountains. This Ellis Martin design is so evocative that it makes you want to be out there with him: which was, of course, the whole point. The Ordnance Survey liked these covers so much that it utilised at least one of the designs in a series of attractive posters and shop display cards.

Other covers for the One-inch map varied in quality and appeal. Martin's *Country Round London* is strangely ill-proportioned and is painted with a curiously erratic sense of perspective. A car pauses at a cross-roads (there is a finger-post); a lady stands up in the back shielding her eyes against the sun (we have seen her before, and we will see her again); a cyclist has dismounted and is talking to the gentleman whose chauffeured car this is; a map is laid out over the tourer's bonnet. We are in open country but away in the distance we can just see the spire of St. Paul's and the haze of the metropolis. There is not a multi-storied building in sight. If the view ever existed, it certainly never will again.

Our lady with the hand shielding her eyes reappears in Martin's standard and early Tourist Map Series, including *Dunoon and the Clyde*. Her scarf is billowing out in a manner we become familiar with, though her fellow passengers may change. The grumpy-looking man in the back seat on the *Dunoon* cover looks uncannily like Sir Winston Churchill in his black homberg and spotted bow-tie: the driver is dressed in tweeds. A sumptuously-painted sky is full of cream, billowing clouds. It is altogether a more richly painted scene than the *Country Round London*.

There are other groups of Martin covers which suggests a genre. The style of painting used in the *Cairn Gorms** is repeated in other covers such as *Snowdon, The Lake District* and *The Trossachs* – three of the earliest Tourist Maps and all dating from 1920. What is particularly notable about this series is the dominance of nature over humanity in the cover designs. There are no human figures at all in the *Snowdon* or the *Cairn Gorms* covers: there is a lone angler in *The Trossachs*; and two very tiny figures rest on the brow of a heather-clad hill in *The Lake District*, while beneath them the vast panorama sprawls out in an eternity of pale blue hills, water and skies.

* There is an interesting story about the One-inch map of The Cairn Gorms (sic) which features a wide vista of snow-capped mountains, a sweeping lakeside, and a group of Scotch firs. In a note found among his effects after his death, Martin revealed how he had painted these trees 'from better examples in Southampton Common'!

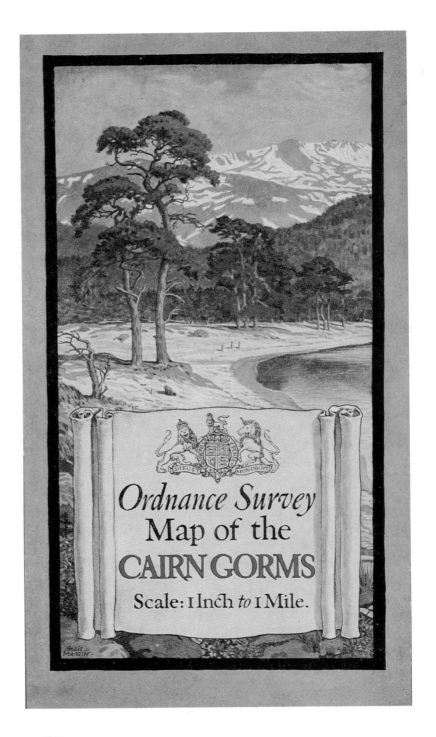

The Cairn Gorms, 1922. Ellis Martin painted the trees 'from better examples found in Southampton Common'!

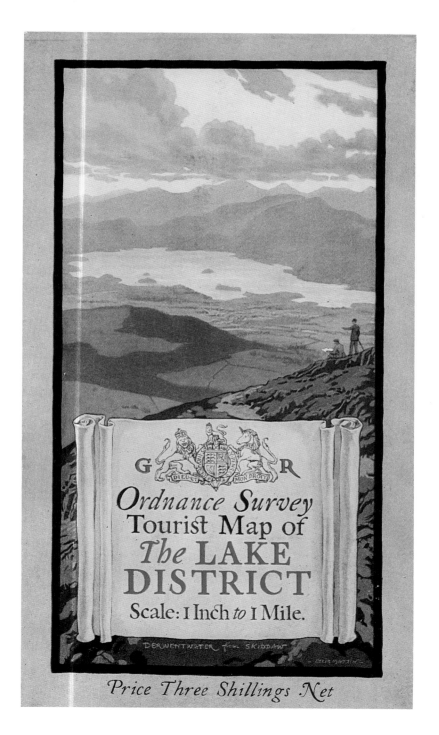

The Lake District, 1920. Derwentwater viewed from Skiddaw in Ellis Martin's majestic panorama.

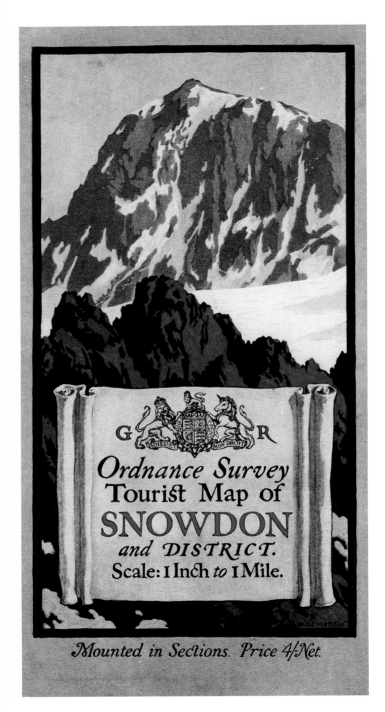

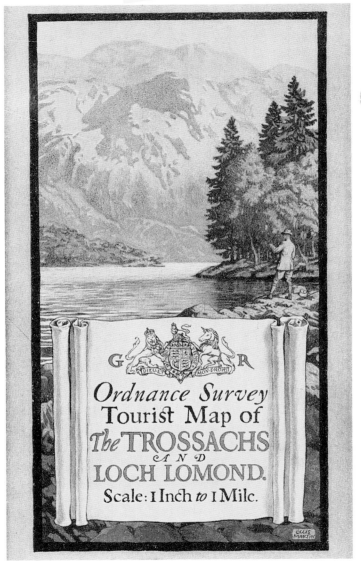

Left: Ellis Martin's *Snowdon*, 1920 – the first Ordnance Survey Tourist Map. In the same year he produced this study of *The Trossachs* for the new Tourist Map range (above).

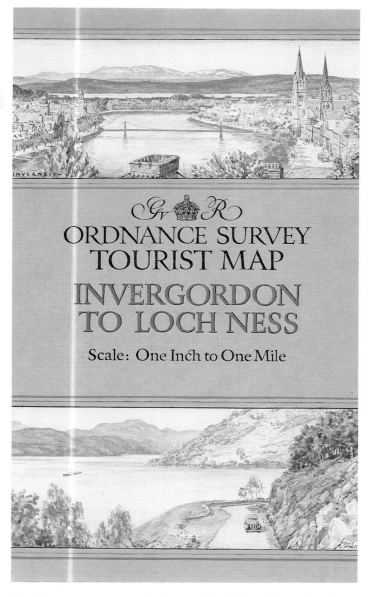

Ellis Martin: *Invergordon to Loch Ness*, 1934 (left) and (right) the River
Wye from Symonds Yat Rock, 1929.

Invergordon to Loch Ness had the unusual device of showing two landscapes on the one cover, separated by the map's details – a One-inch Tourist map. Ellis Martin's original colour artwork for this cover has survived. The effects are not pleasing: the wide format of the two drawings makes composition difficult. The Martin illustrations look as though they have had their tops and bottoms trimmed off, or that the observer is looking at the landscapes through a letter box.

By contrast, his cover for *The Middle Thames*, 1923, is a picture crammed full of figures. Regarded by many as Martin's finest cover, it is a remarkable illustration, crowded with detail but never fussy. Set into a solid black border, the picture bursts open on a busy river full of pleasure boats (Boulter's Lock at Maidenhead). The scene is full of men in white slacks and ladies with parasols. We can barely see the water in the foreground, but beyond the lock the blue-hazed landscape beckons the holiday-makers. The artwork is pure Impressionism.

The cover represents the high point in Ordnance Survey map cover art. It shows what Ellis Martin could do at the height of his powers. Although in some later covers he was to produce remarkable illustrations, he was never to surpass his work on *The Middle Thames*.

One of the Martin's most unusual cover designs was that which he produced for the *Eclipse Map* to celebrate the total eclipse of the sun on 29 June 1927. Prepared jointly with the Royal Society and the Royal Astronomical Society, the map purported to show the times and places across Britain where the eclipse might be seen on that day.* Martin's striking design concept shows the eclipse above an eerily still landscape of silhouetted elms and dark, rolling hills. Although the lettering appears at a glance to have been typeset, everything on the cover – from the royal crown and map title, to the long description of the map – was hand written by the artist. The elegant calligraphy is perfectly justified on both columns.

The sense of occasion and precedent for producing a map of such a limited useful life can best be appreciated if we can imagine the excitement of the event. In a poem, *Hampstead Eclipse 1927*, Bryan Guinness (Lord Moyne) has captured the bustling flavour of the day – see page 91.

* To the intense embarrassment of all concerned, a number of scientific errors were discovered in the map, almost on the eve of publication and thus too late to correct or to withdraw the map. It caused a furore at the time, with letters to *The Times* stoking the controversy. The effect, so far as modern map collectors are concerned, has been to add an extra curiosity value to an already scarce and collectable item.

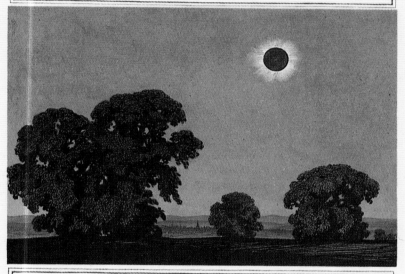

Ordnance Survey
ECLIPSE MAP

THIS *Map, on the Scale of* Ten Miles to One Inch, *has been prepared in conjunction with the* Joint *Permanent Eclipse Committee of the* Royal Society *and the* Royal Astronomical Society. *It shows* Times *and* Places *where the* TOTAL ECLIPSE OF THE SUN *can be seen in* England *on* JUNE 29th, 1927.

Price: Three Shillings

HAMPSTEAD ECLIPSE, 1927

E-clipse glasses one penn-E
See Sun and Moon
Joined in a ring:
Darkness, their child
Astraddle the world
E-clipse glasses one penn-E

Evening. Cigarettes. Morning. Chocolates. Paper.
The little dog laughs
To see the fun;
And the Night runs away
With invisible Day.
Evening. Cigarettes. Morning. Chocolates. Paper.

Twang; honk, tang, tang, Claxton: Charleston.
A tattered cap
Sips copper pap
The engines grind
The mud sings
Tang; honk, tang: tang, Claxton, Charleston.

Sadly a mantle of rain
Casts its neglected jewels
Impartially on shoulders.
On the black webbed wings
Of the shifting crowd
Gleams sadly a mantle of rain.

The stars in their courses
Mute as cricket-balls
Roll,
Fall,
Fixed: invisible:
The stars in their courses.

Ordnance Survey curiosity: a map valid for only one day in 1927, and with no expense spared. Ellis Martin's painstakingly hand-lettered cover and eclipse painting failed to conceal the fact that all was not well with the map itself . . .

STOPHAM,
PULBOROUGH,
SUSSEX

G R

ORDNANCE SURVEY
TEN-MILE
AVIATION MAP
OF GREAT BRITAIN
IN THREE SHEETS

SHEET 1
PRICE 6/-

PUBLISHED BY THE
ORDNANCE SURVEY OFFICE
SOUTHAMPTON

Opposite: De Havilland *Moth* in a simple Ellis Martin cover much used in the 1930s. Much more elaborate was Martin's exciting aerial panorama with the De Havilland *Hound*, painted in 1929.

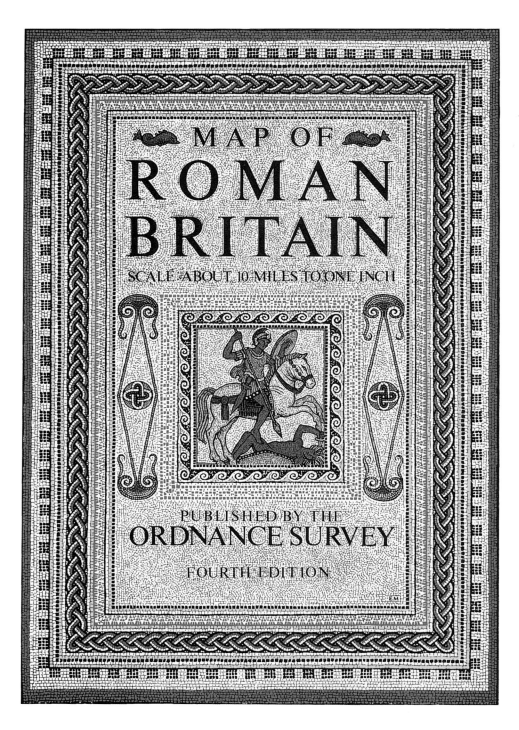

Ellis Martin created this meticulously detailed mosaic for the Ordnance Survey's best-selling map of *Roman Britain* in 1924. The cover design was still in use up to the end of 1990 – the last survivor of the great days of map cover art.

Opposite: Designs by Ellis Martin for a range of 'archaeological and historical' maps.

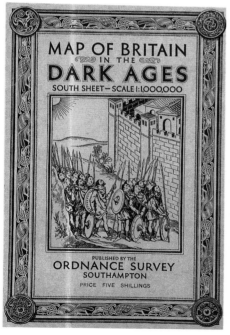

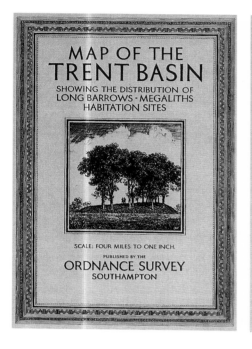

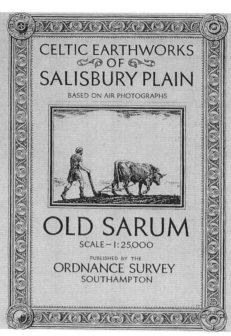

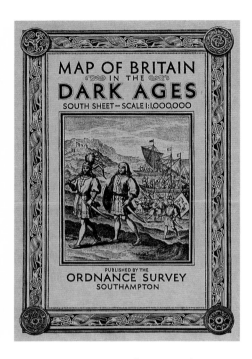

Unused cover design by Ellis Martin showing 'the Arryval of the first Anceters of Englishmen out of Germanie into Britaine . . .', from a plate published in Antwerp in 1605. The Ordnance Survey's Director General rejected the design because it 'represented an Elizabethan view of the Dark Ages'.

Although Ellis Martin maintained a high level of quality – irrespective of the product or the medium – there were, of course, illustrations which fell below his usual standard. Some, like his 'Special District Map' of the *Wye Valley*, printed in black and a dull olive green, definitely show the artist at low ebb. The shortcomings of the map are due to a failure of imagination and have nothing to do with the use of two colours. To understand the point, compare his aerial view of the very detailed landscape, over which a biplane circles (the Quarter-inch *Aviation Map*) which is also printed only in two colours, but has a breathtaking sweep completely missing from the Wye Valley cover. The *Aviation Map* is one of Martin's less well-known designs, but it is one of his best and most imaginative, drawn as it is from a wholly fictitious vantage point high above ground level, possibly with the aid of aerial photographs.

Generally, Martin was able to sustain his creative imagination across an extraordinarily diverse group of products. A further group of important cover illustrations he produced were those for the Ordnance Survey's Archaeological and Historical map series. The first map in the series was that of *Roman Britain*, published in 1924. In keeping with the other covers in the series, the design was a monochrome pen-and-ink illustration. It shows, in painstaking detail, a fictitious Roman tiled pavement surrounded by an ornate interweaving pattern reminiscent of early Celtic art decoration. The centrepiece is a representation of the memorial sculpture on the tombstone of S Valerius Genialis, a Frisian trooper in the Thracian cavalry.

The first and second editions of *Roman Britain* carried Martin's initials discreetly worked into the elaborate tile drawing in the lower-right corner of the cover design. When the third edition was published in 1956, the initials had been quite deliberately removed and the space made up with more tile drawing. The Ordnance Survey had embarked upon its policy of anonymity. It was not until a late reprint of the fourth edition in 1988 that, following a general appeal from Martin afficionados, the Director General of the day, Peter McMaster, authorised the restoration of the artist's initials.

By this time, the original monochrome cover design had taken on a cloak of mosaicists' colour tints and Martin's elegant Roman calligraphy had been replaced by typeset lettering. But it was still Martin's work; and sixty years after he first produced this remarkable drawing it was still in print. As for the other maps in the Archaeological and Historical series, Martin produced attractive but unremarkable covers for a map of *Neolithic Wessex* (1932), *The Trent Basin* (1933), *17th Century England* (1930), with portraits of Cromwell and Charles I, *Celtic Earthworks of Salisbury Plain* (1933), and a few others.

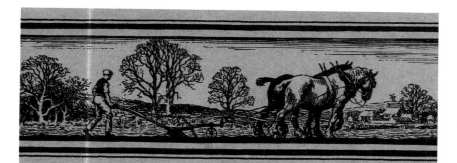

Land Utilisation Map
of England & Wales

BASED ON THE

"One-Inch" Ordnance Map

SHEET 58

CROMER

PRICE 5/- NET.

Printed and Published for the
LAND UTILISATION SURVEY OF GREAT BRITAIN
by the Ordnance Survey, Southampton.

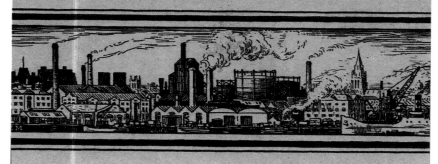

Rural and industrial Britain succinctly
portrayed by Ellis Martin, 1933

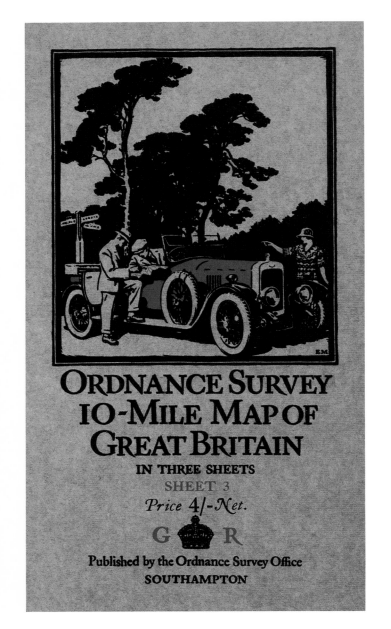

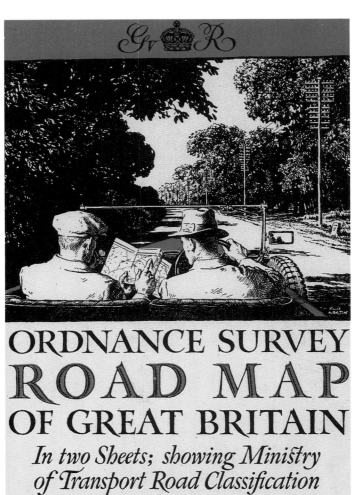

Elegant Ellis Martin cover for 1925 and later editions of the Ten-mile map.

'The road ahead by day': another Ten-mile map cover design by Martin in 1932.

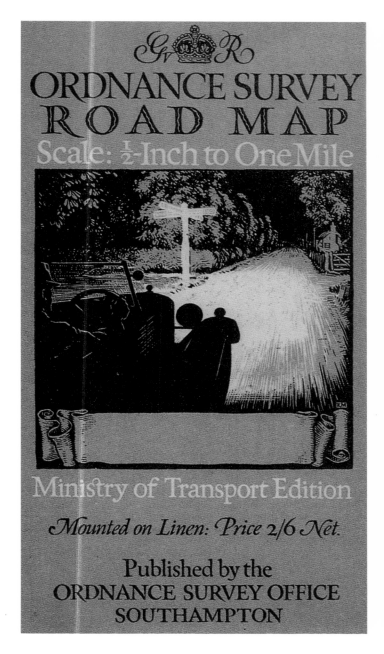

'The road ahead by night'. This atmospheric Ellis Martin design was rejected in favour of Arthur Palmer's miserable 'charabanc' drawing shown on page 41.

Standard cover design by Ellis Martin, used on a wide range of Small-scale maps from 1919 to 1939.

This remarkable crowd scene by Ellis Martin first appeared in a monochrome version in 1934. The red-lettered London version came in 1936.

The River Thames downstream from Hungerford Bridge: this handsome view as painted by Ellis Martin for the Six-inch map of 1920.

The last of Ellis Martin's 'group' covers were the thematic designs, the most important being his *Population Map* of 1935 in which a sea of heads - nearly all wearing hats – fills a crowded picture. This design appeared in two editions – a general population consensus of England and another of London in 1935. There were others – a Half-inch map of *London* (1935) and a *Land Utilisation Map*.

As well as these groups of stylish covers, Martin produced a number of attractive designs for other map series, the Six-inch Town Maps among them. Most important was the very handsome Six-inch map of *London* with its twilight view of the Thames and the City from the Embankment. He also produced a set of Road maps, including a version of the Ten-mile map with its *art nouveau* black and red cover. In another, an open tourer has paused in a country lane; the driver and his passenger are looking at an unfolded map. We, the viewers, are in the back seat, looking over the driver's shoulders. This imaginative concept is best described as 'The road ahead by day' which distinguishes it from Martin's cover called 'The road ahead by night' which reached printed proof stage but was never used on the projected *Ministry of Transport Half-inch Road Map*. Instead of Martin's atmospheric cover, the public were given Arthur Palmer's worst cover design – the poorly drawn 'woodcut' of the trundling charabancs.

Martin's career with the Ordnance Survey was drawing to a close – although he did not know it – as events moved towards another world conflict. As 1939 approached, official attention was once again diverted away from the sale of tourist maps to the public. Economic restrictions were imposed in several areas of the Department's work, and map cover design was one area which the Department felt that it could do without. Ellis Martin's post was abolished on 2 November 1940 and he was, in effect, made redundant. In a note to the Department, he offered to 'return when things have settled down', but the offer was never taken up.

Martin retired to Sussex where some members of his family lived (and still do). He continued to paint but widowerhood and increasing loneliness turned him into a wilful and cantankerous old man. Eventually he agreed to take up residence in a nursing home, but his last years were marred by creeping deafness which further isolated him. He died on 30 September 1977 at the age of 96.

Ellis Martin was not a great artist in the way that some of his Slade contemporaries, such as Augustus John, may have been. But as an artist whose chosen career was commercial or functional art, he was in a class of his own.

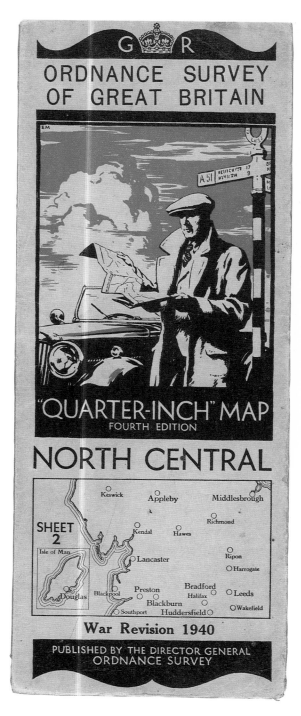

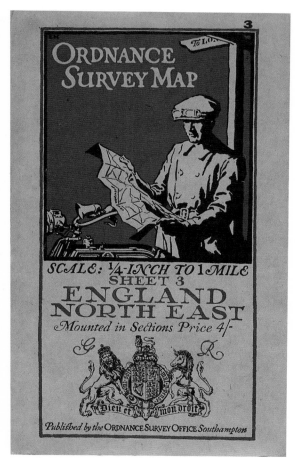

The Quarter-inch map received several
treatments from its cover artists. Martin's
motor-cyclist first appeared in 1919, the
motorist in 1934. This 'War Revision' edition
was in use after Martin's retirement in 1939.

ORDNANCE SURVEY
MAPS
for Motoring Cycling & Walking

¶ *These* are the *Official Maps* of the Country; & the new and revised Editions *at popular prices* on the scales of 1-*inch*, ½-*inch*, & ¼-*inch to one Mile*, now obtainable at all the principal Booksellers & Railway Bookstalls, are ideal for every touring purpose.

Advertisement designed at the Ordnance Survey Office

DIEU·ET MON·DROIT

¶ Published by the ORDNANCE SURVEY OFFICE Southampton

ORDNANCE SURVEY
MAPS

THE enjoyment of a country holiday—whether Motoring Cycling or Walking—is greatly enhanced by the possession of a really first-class MAP.

¶ At all the principal Booksellers & Railway Bookstalls *ORDNANCE SURVEY MAPS* may now be obtained.

¶ *These* are the *Official Maps* of the Country; & the new and revised Editions at popular prices, on the scales of 1-*inch*, ½-*inch*, & ¼-*inch to one Mile*, are ideal for every touring purpose.

G R

ORDNANCE SURVEY OFFICE, *Southampton.*

Advertisement designed at the Ordnance Survey Office

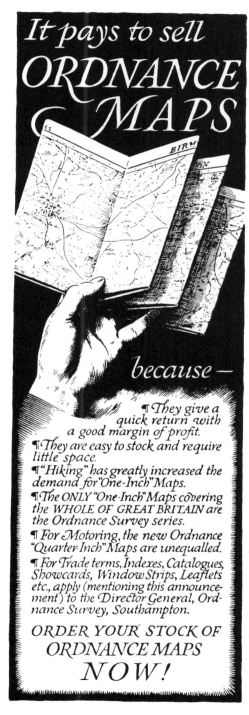

It pays to sell
ORDNANCE MAPS

because —

¶ They give a quick return with a good margin of profit.
¶ They are easy to stock and require little space.
¶ "Hiking" has greatly increased the demand for "One-Inch" Maps.
¶ The ONLY "One-Inch" Maps covering the WHOLE OF GREAT BRITAIN are the Ordnance Survey series.
¶ For Motoring, the new Ordnance "Quarter-Inch" Maps are unequalled.
¶ For Trade terms, Indexes, Catalogues, Showcards, Window Strips, Leaflets etc., apply (mentioning this announcement) to the Director General, Ordnance Survey, Southampton.

ORDER YOUR STOCK OF
ORDNANCE MAPS
NOW!

Ordnance Survey Leaflets: No. 1.

ORDNANCE SURVEY
MAPS FOR TOURISTS
Notes on
the Choice of a Scale.

G ♔ R
Ordnance Survey Office,
Southampton.

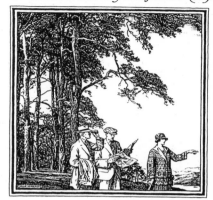

Ordnance Survey Leaflets: No. 3.

THE NEW
Ordnance Survey Map
of SCOTLAND
on the Scale of One Inch to One Mile
(Popular Edition)

G ♔ R
ORDNANCE
SURVEY OFFICE
SOUTHAMPTON

Point-of-sale display cards and advertisements by Ellis Martin. All the lettering is hand-written by Martin, using alphabets which he designed. *Ordnance Survey Leaflet No 1* shows a customer examining maps which evidently bear Martin's own cover designs, and 'the lady shielding her eyes' is on a display card behind the shop-keeper!

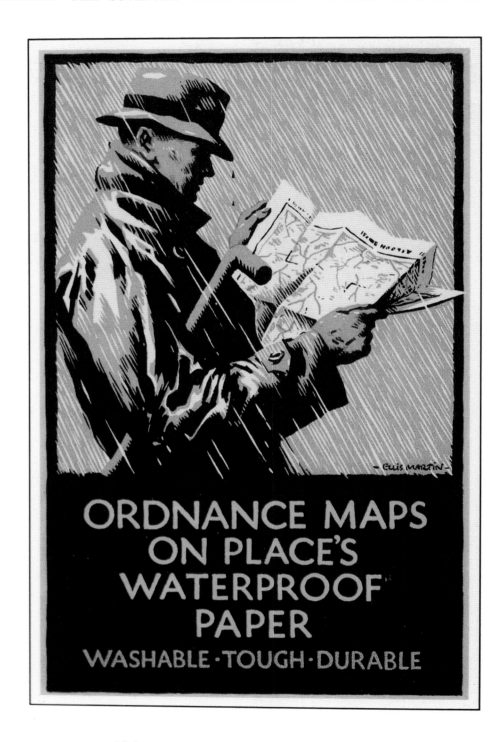

Ellis Martin display card advertising maps on
Place's waterproof paper.

Ellis and Mabel Martin

It would be nice to be able to say that he created the style of 1920s and 1930s domestic art. But that is too extravagant a claim to make on his behalf. It is certainly true to say that he was the embodiment of that style, and it is also true to say that he exercised considerable influence over other practitioners in the genre. We can see his mimics in the work produced by rival commercial map publishers, even if few of them approached the high level to which he took his art. We can also see Martin's influence in the motoring and cycling journals of the period and in the railway posters which sought to mobilise the population.

The artist, sculptor and writer, Sven Berlin, has described the Ordnance Survey maps of the 1920s and 1930s as 'old friends who guided you to unknown places', and this sort of friendliness started with the beguiling covers which Martin, Palmer and the others produced for those maps.

Martin has left behind such a body of work, not only for the Ordnance Survey, but also for other organisations and publishers, as well as an extensive collection of private pictures, that a book of this scope cannot itemise it comprehensively. When he left the service, Ordnance Survey map cover art would never again capture a period so effectively as it did under his leadership. Ellis Martin was the Cycling Age and the Motoring Age and the Rambling Age personified: when we think of the maps produced for those leisure pursuits, we tend to think of Ellis Martin.

When the Ordnance Survey returned to the publication of leisure maps after the Second World War, the covers which went with them reflected post-War austerity. They were bereft of the innovation and imaginative flair which characterised the inter-War years. In short, Ordnance Survey map cover art was to reach its nadir in the post-war years.

THE LATER ARTISTS

T HE YEARS FOLLOWING THE SECOND World War were marked by a gloom which found bleak expression in many facets of Ordnance Survey life. The old offices at London Road were beginning to show their age, quite apart from the ramshackle condition in which the 1940 bombing raids had left them. The Davidson Committee of 1938 had recommended a number of 'core' activities to be undertaken by the Ordnance Survey, among them the introduction of the large-scale 1:1250 maps for urban areas and – more relevant to our story – a new series at 1:25 000, or 2½ inches to the mile scale.

With the War behind it, the Ordnance Survey now set out to implement the Davidson Committee recommendation.

The 1:25 000 series called for a new set of cover designs to supplement the new designs for the Tourist, District and special areas maps now being taken out of mothballs. By and large, these new cover designs reflected the dourness of the period: the old-fashioned beauty of Palmer and Martin was replaced by an ugliness which, fortunately, was short-lived, although not before a great many maps were covered with designs of awesome mediocrity.

Martin was gone, prematurely retired; Palmer had left, his career having run its course. These were the two bright lights of Ordnance Survey map cover art in the inter-war years. To look at their work we can see that they had all the time in the world in which to produce their attractive illustrations. To judge from the examples of unused artwork which Palmer has left behind we can see that he had time enough to make several attempts at a cover, taking a piece of art to near completion before rejecting it – or having it rejected – and starting again.

* Map cover competitions for the One-inch and Half-inch maps started in 1949. One regular competitor was Corporal C.I.Vann, a lithographer at Waddon whose work, though sometimes taking first prize in the competitions, has not appeared on published maps. Competitions for designs to cover other maps had been going on for some time with prizes ranging from £3 to £10 being offered to winners. R.A. Jerrard was among the competitors of 1946.

Full circle: map cover art returns to the functional austerity of pre-1914 days.

From now on map cover art was to be in the hands of graphic designers rather than pictorial artists. It all looked very modern in its day and the brashness of the new designs certainly pleased a good many. Some of it came about as a result of competitions* held in-house. However, design suggestions were tightly controlled and there was little room for artistic scope. The Ordnance Survey fondness for formal lettering kept intruding and the need for standard cover information rather restricted any design inventiveness.

In some ways the new designs anticipated later computer graphics, but without the colour and panache. One customer wrote to complain: '*What a pity the sober dignity of your map covers have given place to a jazzy design on the Quarter-inch sheets.*' This was also the period when the Ordnance Survey began to show an interest in photographic covers: the *Lake District* Tourist map was the first to be presented in such a cover. A dull and much retouched photograph by Alfred Furness, taken from his book *The English Lakes*, replaced Ellis Martin's handsome watercolour in 1948.

Stanley Phillip Reeves was a Signalman in the Royal Signals before he joined the the Ordnance Survey in 1946 as a compositor. Later he became a letterpress operator until eventually becoming involved in map cover design. Reeves was no artist, but he had a flair for simple, geometric design, and it was as a 'typographic designer' that he first made his mark on Ordnance Survey covers. By 1963 he was a 'full-time designer' and ten years later his supervisor was recording that 'the Department is fortunate in having a man of his abiliity and diligence.'

Reeves created the house style which incorporated the Royal Arms (or the Scottish Arms where appropriate) in a usually black rectangle, which first appeared at the top-left corner of the 1963 *Annual Report*, and on subsequent maps. He turned out about twenty covers between 1964 and 1968, including the 1:25 000 First and Second Series with their distinctive magnifiying glass motif on blue and green respectively. For those readers interested in such things, the map areas enlarged by the magnifying glasses are made up of fictitious place-names superimposed on factual topographic detail - an elaborate cartographic tease.

When the Central Office of Information took over the design of Ordnance Survey publications in the late 1960s, Reeves was called in to advise on house styles and Departmental requirements, so that his influence on map cover design continued for some time after the Ordnance Survey had shed this side of its work. Reeves died in 1977 at the age of fifty-nine, after thirty-one years with the Ordnance Survey.

The Central Office of Information, as official designers, produced

Opposite: Stanley Phillip Reeves, typographic designer-turned map cover artist, introduced the Ordnance Survey house-style symbolised by the usually black rectangle containing the Royal or Scottish Arms in the top-left corner of his designs.

* See footnote on page 108

Cartographic teases: the map detail is authentic but all the names are fictitious. These were the covers for the 1:25 000 First Series (blue) and Second Series (green), examples of both being available in 1965.

unemotional and rather aloof illustrations. '*In introducing this style*', said the COI, '*we are endeavouring to produce a range of covers which will be both modern in appearance and more readily recognised by the general public as symbolising the best in mapping.*'

The unimaginative but certainly recognisable scarlet covers of the One-inch map, which was now in its Seventh Series, were largely derided by the more aesthetic critics:

> As a lifelong collector of maps I have watched with sorrow the decline from the illustrated covers of former years to the stark, impersonal creations of today. My latest sheet is clothed in shiny, plastic-like paper that is positively hygienic. You could eat off it, or, in the extremity, you could boil and eat the thing itself, What hint is there that beneath this passionless breast there beats a heart of gold?

Central Office of Information designs for two 'period' maps of 1976 (left) and 1974.

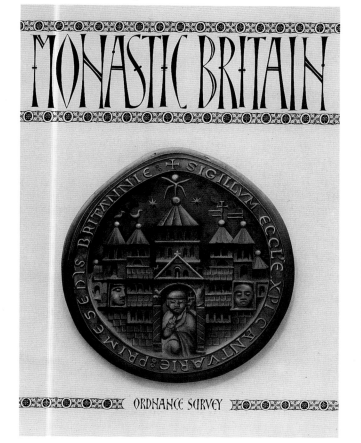

A new Ordnance Survey logo, the broad arrow and stylised initials first appeared in 1969. The scarlet One-inch cover for the Seventh Series was hotly denounced in the Press by critics who still remembered Martin and Palmer. The COI's black-border covers were popular for a time in the early 1970s, even though the drawing of Ashness Bridge in the Lake District (below) was printed back-to-front!

This was D.Macer Wright again, not so much lamenting the passing of the old-style covers as decrying the absence of artistic quality or even the need of such a quality in the new products.

The new-wave Tourist Maps appeared with pictorial covers straight out of a design shop; stylised drawings in strange colours. What would Ellis Martin have thought of the new map of *The Trossachs* with its spidery pen drawing and its patches of unrelated colours? Well we know what he thought of it when he was asked for his opinion as he lay in his bed in a Sussex nursing home: 'Too much yellow!'

Nevertheless, the series was attractive in its way. The solid black borders with the map details reversed out in white made a dramatic surround for the bright pictures. Each tourist area had its own distinctive illustration: there were ten sheets at One-inch (based upon the regular Seventh Series which itself was about to be replaced by the metric 1:50 000 map), one at a Half-inch scale – *Snowdonia National Park* – and a Quarter-inch of *Wales and the Marches*. The most successful was probably the 1971 *Lake District* cover of Blea Tarn which replaced the *Lake District* cover of the previous year in which the drawing of Ashness Bridge, was, unfortunately, printed the wrong way round. The 1971 cover features a pleasant and well-executed landscape in which the unrealistic colours blend with some sort of harmony. By contrast, *Loch Lomond and the Trossachs* and the *North York Moors* were garish and poorly printed.

By this time the Ordnance Survey had yet another house-style: the broad arrow, representing a magnetic compass needle and an Ordnance Survey bench mark, set into the initials 'OS', had been introduced in 1968. For map covers featuring an illustrated design, a white border around the picture or location map was to be a feature of this new house-style pack for the pocket. The cover livery for the 1:25 000 Outdoor Leisure Map series was a sort of Spanish gold colour which indicated that the mapping within was based upon 1: 25 000 First Series; where an OLM was based upon 1:25 000 Second Series mapping, the cover colour was changed to a very bright yellow. Map details on the cover were in the ubiquitous *sans-serif* letterpress which was almost everywhere replacing the old *Roman* type.

For the covers of this new series, the Ordnance Survey engaged the services of Harry Titcombe, a professional artist and ornithologist then working for the Central Office of Information. The Ordnance Survey had firm ideas about what it wanted for these covers; a bird familiar in the area covered by the map; a plant; and a background scene evocative of the area. Occasionally the instructions, had they been carried out, would have made natural history nonsense (a house martin and a wild pansy were

Ordnance Survey OS
Lake District
Showing part of National Park Boundary

Tourist Map

The area covered by the map is indicated on the back cover

Ordnance Survey OS
New Forest
Showing New Forest Boundary

Tourist Map

The area covered by the map is indicated on the back cover

Ordnance Survey OS
Loch Lomond and The Trossachs

Tourist Map

The area covered by the map is indicated on the back cover

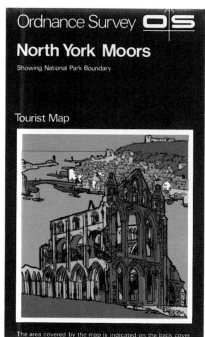

Ordnance Survey OS
North York Moors
Showing National Park Boundary

Tourist Map

The area covered by the map is indicated on the back cover

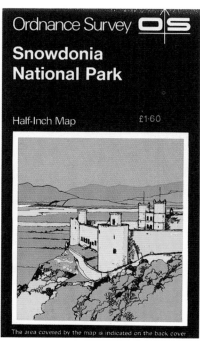

Ordnance Survey OS
Snowdonia National Park

Half-Inch Map £1·60

The area covered by the map is indicated on the back cover

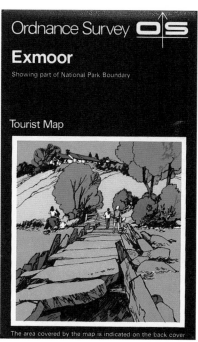

Ordnance Survey OS
Exmoor
Showing part of National Park Boundary

Tourist Map

The area covered by the map is indicated on the back cover

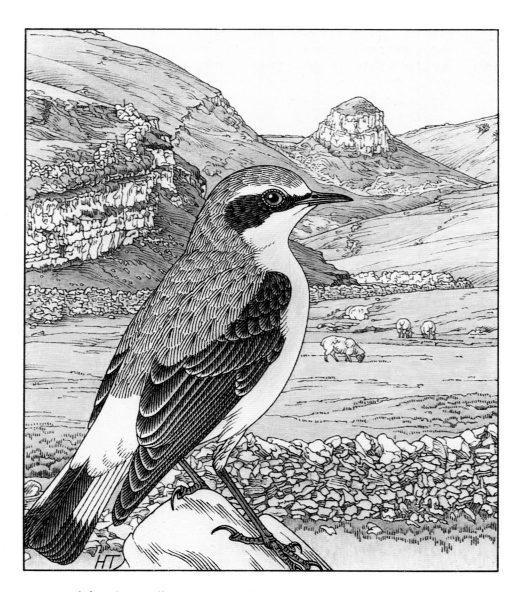

Harry Titcombe: *Wheatear*. One of the 21 attractive ornithological drawings he made for the Outdoor Leisure Map series (though 3 of the drawings were never used). Those in brown borders indicated First Series maps; those in yellow borders were Second Series.

requested for the *Malham* map) and delicate negotiations were sometimes necessary.

By 1981, the Ordnance Survey had begun to commission its own artwork and Titcombe, now a freelance, continued to produce his series of 'bird' covers for the OLM Series. In all, eighteen of his drawings adorn the covers of Outdoor Leisure maps. Three further drawings were never published. Of the published covers *The White Peak*, *New Forest*, and *The Cairngorms*,

are probably the most satisfying, although all the drawings are attractive. The curious combination of raven and daffodils used on the *English Lakes* maps (four sheets cover the area) makes this cover the most suspect from the natural history point of view, even if the combination makes a pleasing picture. Finding a Dartford warbler – a notoriouly shy bird – for his *Purbeck* cover was a masterly touch, and this design, with the ruins of Corfe Castle set on a symbolic view of the Purbeck Hills, is one of the most attractive of the whole range.

While the use of a bright chrome yellow border for the Second Series of the Outdoor Leisure Map may have been a marketing ploy to arrest customer attention in the shops, the darker gold of the First Series actually makes a better frame for Titcome's stylish and stylistic drawings. There was already a lot of yellow in his *White Peak*; the new yellow border tended to swamp the pictorial design; and in the *English Lakes*, the offending daffodils are almost lost in the yellow border.

Titcombe had signed his first cover design but by the time it appeared in print, his signature had been removed. Objecting to this unexpected treatment, he was subsequently invited to sign all future designs, but he contented himself by simply adding the initials 'HT' to his drawings. His full name was, however, soon restored to the *Dark Peak* cover.

The decision made in the 1980s to abandon artwork in favour of photographic covers for most of the Ordnance Survey range of maps brought Titcombe's contract with the Department to an abrupt end. There are many who saw in Titcombe's map cover art a continuation of the Ordnance Survey's generally honourable patronage of gifted artists. The move to photographic covers had nothing whatever to do with an official denigration of the art form itself; new philosophies and new exchequer demands were making marketing managers reappraise the state of map sales. A fresh approach was thought to be necessary, and the time was ripe for new tactics in the war of high street map selling.

In the 1970s, 80s and into the 90s the emphasis on increasing revenue to cover costs has resulted in even greater attention being placed on satisfying customer needs. This affects both map content and the way Ordnance Survey maps are packaged, presented and marketed. The principles identified by the Olivier Committee way back in 1914 – that Ordnance Survey map covers should be durable and attractive – have even more relevance today. Competition for shop shelf space is fierce and a product must earn its keep in the retailer's eyes or be replaced by a better selling competitor. The cover must attract and demand that the map be picked up and opened.

Harry Titcombe.

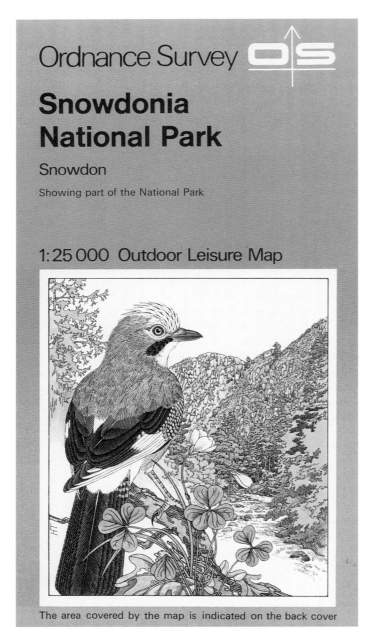

Jay by Harry Titcombe, 1977. It appeared on four of the five sheets of *Snowdonia National Park*.

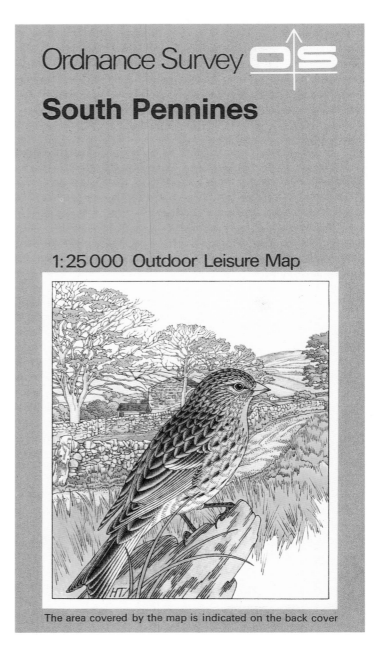

Twite by Harry Titcombe, 1978. Used again for the Second Series of the map in 1984.

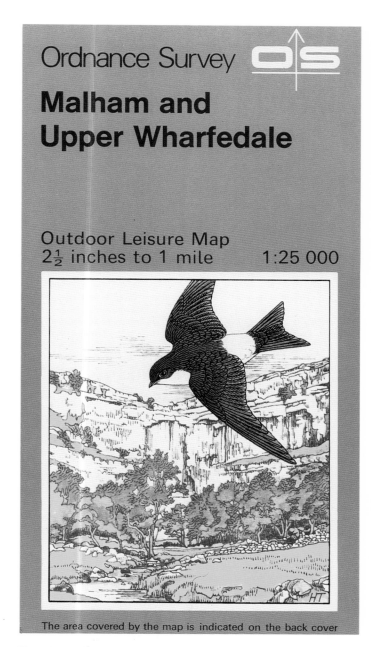

House Martin by Harry Titcombe, 1975.

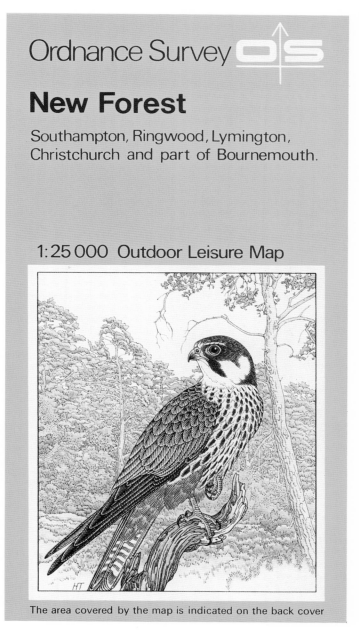

Hobby by Harry Titcombe, 1979.

Ordnance Survey

Aviemore and the Cairngorms

Ben Macdui, Braeriach, Cairn Toul and Cairn Gorm

Outdoor Leisure Map

2½ inches to 1 mile 1:25 000

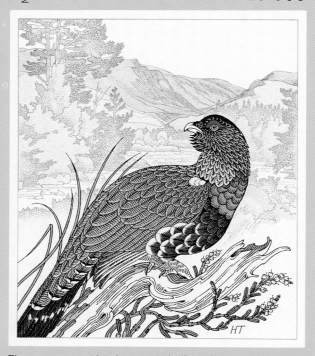

The area covered by the map is indicated on the back cover

Capercaillie by Harry Titcombe, 1982. Earlier editions of the map were called *High Tops of the Cairngorms*.

Ordnance Survey

Purbeck

1:25 000 Outdoor Leisure Map

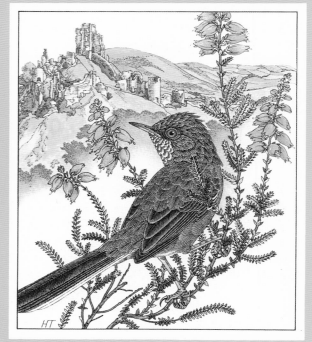

The area covered by the map is indicated on the back cover

Dartford Warbler by Harry Titcombe, 1977.

Gary Meadows and Christine Lewis of the Ordnance Survey's Design Team made these Neighbourhood Map covers in 1984 (showing High Street Crawley) and 1986 (the town centre, Chester-le-Street)

Ordnance Survey map covers are now predominantly photographic, with the title block colour coded according to series and scale. Thus the 1:50 000 scale Landranger Map – the metric replacement for the One-inch – is magenta, *Motoring Maps* at 1:625 000 and 1:250 000 scale are blue and white, Touring Maps at 1:63 360 and smaller scales are red, *Outdoor Leisure Maps* at 1:25 000 scale are yellow, and *Historical Maps* at a variety of large and small scales are a vignetted brown. This colour coding is convenient for customers interested in a particular series and creates a strong visual presence when maps are displayed together: at the same time each map is given interest and individuality by the photograph of a local site or feature.

The story of Ordnance Survey Map Covers is not finished. Packaging design and presentation constantly evolve to meet changes in market trends and tastes. In the cycle of things artist-drawn map covers may well return, prompted perhaps by the wonderful examples of the 1920s and 30s.

THE COVERS

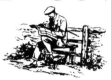

Column 1: Sequential number for easy reference
Column 2: Description of cover design. Most variations in lettering, or changes in the Royal Arms (usually at the death of a monarch), have been ignored. This list also disregards cover back panels and inside surfaces
Column 3: Initials of artist. See the list on p.144
Column 4: Map issues which use the design. The dates given are those of the first publication of an edition, and the appearance of a cover design is usually coincident, or soon after. Dates with an asterisk denote those for which there is supporting evidence for the independent introduction of a cover design. The titles given are usually the sheet rather than the cover title, except on Ansell-fold maps. Cover titles altered by means of adhesive labels have been disregarded. Matter in square brackets gives additional or editorial information

This list is not definitive, and the absence here of a particular type of map inside a particular cover design merely means that it has not been recorded, not that it does not exist. However some whose existence is suspected are included, guarded by question marks. Many designs were used also on publicity leaflets and posters etc., but these are only noted here if they assist in dating the design. Words such as 'long', 'wide' are comparative and imply no fixed measurement. *Kew Gardens*, 1935 is the only known map advertised in covers not so far recorded.

GENERAL PURPOSE MAP COVERS
The first Ordnance Survey covers were cloth-coated, and were intended almost entirely for general purposes. The remnant of this tradition survived until 1959 on *Isles of Scilly*, 1933. Such covers were issued on maps at scales from 25 inches to the mile to 25 miles to the inch. Many of these would have been issued in thin paper envelopes, some with Fisher Unwin's imprint. In Nos 1-3 below, 'short' implies dimensions of approximately 100 x 160 mm, 'tall' 95 x 180 mm

The miniature reproductions in this Chapter illustrate the 199 primary map cover designs listed. The number which appears against each illustration corresponds to the sequential number in the list (column 1).

Variations in the primary cover designs are not illustrated.

1 Textured red cloth
 1 Title label, book-fold
 2 Gold printing, adhesive

For use on colour-printed maps, 1897. Tall and short formats recorded
Recorded only on engraved One-inch maps

2 Central title panel, red cloth, adhesive

For use on engraved One-inch maps. With sheet name. Narrower covers also have series numbers: the maps in these are trimmed to the neat-lines

3 Title panel spanning cover

Sheet name or series number titles used. Serif and sans serif lettering. Some covers (?printed in Dublin) have distinctive colours and arms

 1 Short oblong
 a Red book-fold
 b Red slip case
 c Red cloth-hinged
 d Book-fold, blue card
 2 Tall oblong
 a 1 Red hinged
 2 Red book-fold
 b 1 White hinged○
 2 Location map added
 3 White book-fold
 4 White adhesive○
 c Direct printed covers

General purposes, c.1900
Recorded only on Half-inch Manoeuvre Maps, 1903
?General purposes, c.1903; recorded mainly on Half-inch maps
Royal Parks: Hyde Park & Kensington Gardens [Twelve-inch map], 1906
Some marked "W.D." for "War Department", or "P.S." for "Public Service"
General purposes, 1904
General purposes
General purposes, 1906-c.1918. A 1:100,000 map of *Metz*, 1907 is recorded!
England & Wales Half-inch Manoeuvre Map, 1909/1910/1911/1912
General purposes
General purposes: originally for dissected maps. Dimensions variable
For military use●

4 Location map, white
 1 Hinged
 2 Adhesive
 3 Direct printed covers

For use on small-scale series/district coloured/outline maps, 1910
General purposes
General purposes: originally for dissected maps. Dimensions variable
For military use●

5 Series number or sheet name

Direct printed covers, or via a label●. For military use at home and abroad

6 Index diagram

Direct printed covers, or via a label●. For military use at home and abroad

7 "Ordnance Survey" redrawn
 1a Location map, white cloth
 b Title panel, white cloth○

 2a Location map, buff card
 b Title panel, buff card○

Mostly on adhesive covers: post-1924 issues use the "Official" Royal Arms
For use on small-scale series/district coloured/outline maps, c.1918
General purposes, c.1918. A surprisingly late example of it is recorded on:
South Central [Quarter-inch District Map], 1924
Mostly recorded on One-inch outline District Maps with sienna roads, c.1921*
For maps lacking individually styled covers, c.1921. Special maps include:
Taunton [One-inch Popular Edition sheets 120/129 conjoined], c.1924
Royal Parks (Richmond Park) [Ten-inch map], 1926

8 "Official" Royal Arms
 1 Single lineation on buff
 a Black arms and red
 1 With location map

 2 No location map

 b Red arms and black
 2 Waved lineation on buff○
 [See No 80]

Used on official publications from 1924. Enlarged, it was the feature on:

One-inch England & Wales Popular Edition District/Tourist Maps, c.1927*
One-inch England & Wales/?Scotland Third Edition District Maps, c.1927*
Half-inch Special District (Relief) Maps: *Island of Skye*, 1932/1937; *Birmingham District*, 1933 [published 1934]. See No 24▽
Isles of Scilly [Two-inch Special District (Relief) Map], 1933△
?One-inch England & Wales/Scotland Engraved Black Outline Series
One-inch England & Wales/?Scotland War Revision/Second War Revision, 1940
One-inch England & Wales outline District Maps with sienna roads
Taunton [One-inch Popular Edition sheets 120/129 conjoined], c.1928*
Marlborough [One-inch Popular (Special Edition, with Hills) sheet 112], 1931

3 Double lineation
 a Red on white paper — Six-inch [black] Town Maps, 1931●
 b Black on buff card/paper
 1 Standard format — *Norfolk Broads* [One-inch Special Sheet Popular Edition], 1932. See No 24▽
 2 Large portrait format — *London Passenger Transport Map* [One-inch Popular Edition], 1934
 3 Long format — *Main Roads of London* [One-inch map], 1934 [published 1935]
 4 Large landscape format — Six-inch sheets; Agricultural Atlases
 c Ansell-fold maps▲
 1 Turquoise boards — *Road Map of Great Britain* [Ten-mile map], 1932/1935 [published 1937]
 2 Brown boards — *Fully Coloured Map of Great Britain* [Ten-mile map], 1932*
 3 ?Blue boards — *?Quarter-inch Map of Scotland*, c.1932*
 4 Red boards — *3-inch Map of London with Gazetteer*, 1933
 d Atlas, turquoise boards — *Routes Through Towns*, 1934 [published 1935]

THE INTER-WAR YEARS, 1919-1939

Relatively few, usually obsolescent, maps remained in Ordnance Survey general purpose covers. For most, new pictorial designs, individually styled to establish a separate identity for each map series, were created. Adhesive cards were generally used, and on extant maps these were often glued onto ex-military stock, and a few were even glued to pre-war hinged covers. Paper book-fold covers were briefly revived on some cloth Half-inch and One-inch Third and Popular Edition maps, and were in standard use on paper maps. Hinged covers regained their popularity in 1930, to be superseded by the current "Bender" fold (named after its inventor, not its method of folding) for non-dissected maps from 1938, though they did not finally disappear until 1962. N.B. The term "District Map" is conventional, and before the 1930s was only used as part of the map or cover title. Phraseology such as "Parts of Sheets . . ." or "Special Sheet" was preferred for sheet designation.

Covers designed for national map series

9 Four nations' shields and ? One-inch England & Wales Coloured Edition: Third Edition, Large Sheet Series,
 foliation, grey c.1916*. ?An experimental cover, recorded only on sheet 126

10 The Royal Arms with mantling EM One-inch England & Wales/Scotland/Ireland Coloured Editions, 1919*
 1 Black, red sheet name England & Wales Third Edition, Large Sheet Series sheets/District Maps
 2 Dark red and brown England & Wales Third Edition, Large Sheet Series sheets/District Maps
 Scotland Third Edition/Ireland series sheets/District Maps

11 Cyclist seated on hillside EM One-inch England & Wales Popular Edition
 1 Black, red sheet name
 a With location map Series sheets except sheet 140, 1918 [published 1919]
 District Maps: *Aldershot District (North)/(South)*, 1914
 b With placename list Sheet 140, 1919
 c *Place's Paper* legend Series sheets on Place's Waterproof Paper, c.1930*▽
 d With oval price panel ?Unused design for Popular Outline Edition
 2 Dark red and black
 a With location map Series sheets except sheets 17 and 140, 1919*. See No 76
 District Maps: *Aldershot District (North)/(South)*, 1914/1919; *York District*, 1919;
 Salisbury Plain, *The Aldershot Command*, 1920
 b With placename list Sheet 140, 1919
 c With Stanford's addresses Coloured/outline series sheets/District Maps dissected and sold by Stanford
 d Black sheet name Series sheets, 1939*

12 Car passing signpost EM Half-inch Layered/Hill-shaded Editions
 1a Black, full red title England & Wales series sheets, 1919*. Recorded only with book-fold covers
 b Black, red sheet name England & Wales series sheets, 1919*
 ?Unused design for England & Wales One-inch Popular Edition
 2a Green and brown England & Wales/Scotland/Ireland series sheets/District Maps, 1919*
 b Brown sheet name England & Wales/Scotland series sheets, 1939*

13 Motor cyclist at signpost EM Quarter-inch Third Edition/Third Edition (New Series)
 1a Blue and black England & Wales/Scotland series sheets, 1919▽◊
 b Black sheet name England & Wales/Scotland series sheets, c.1932*
 2 Brown and black District Maps: *South Central*, 1924; *Glasgow and District*, 1930
 England & Wales series sheet 2A [*North Central*], 1926

14 A31 signpost near Hursley AP Ministry of Transport Road Map, 1923. Probably a woodblock design
 1 Black on orange paper Half-inch England & Wales/Scotland series sheets
 2 Dark red on orange paper *London* [Two-inch map]

15 The road ahead by night EM ?Unused design for Half-inch Ministry of Transport Road Map

16 Scottish lion rampant EM One-inch Scotland Popular Edition
 1 Thistles, small format Series sheets, 1924
 2 No thistles
 a Long format Series sheets, c.1928*
 b Standard format Series sheets, c.1929*▽. Issues exist with only the superscript wording
 c Black sheet name Series sheets, 1939*

17 Red Sunbeam at signpost EM Ten Mile Map of Great Britain, 1925 [published 1926]/1936 [published 1937]. An
 ?unused variant for sheet 2 has a border of alternating roses and thistles

18 De Havilland Hound overland EM Quarter-inch Aviation Map, Civil Air Edition
 1 Wide format England & Wales/Scotland Third Editions, 1929*
 2a Long format England & Wales/Scotland Third Editions, 1934
 b No location maps Scotland Third Edition sheet 10, 1934

19 De Havilland Moth in octagon EM Other Civil Aviation Maps
 1 Blue octagon Ten Mile Aviation Map
 a Small format Great Britain Special Air Edition (Provisional), 1929*/Air Edition, 1930
 b Long format Great Britain Civil Air Edition, 1934
 2 Green octagon 1:1,000,000 International Local Aeronautical Map: NN-31 *Amsterdam*, 1936
 [published 1937]; NM-30 *London*, NN-30 *Edinburgh*, 1939
 3 Red octagon 1:500,000 Aviation Map of Great Britain, 1937 [published 1938]
 A crown and garter design, intended as the new Ordnance Survey trade mark,
 reached proof stage, but was not used

20 The Royal Arms with mantling EM One-inch England & Wales Fifth (Relief) Edition
 surmounting scrollwork Series sheets 144, 1931; 137, 145, 1932
 Special District (Relief) Maps: *Aldershot, North/South*, 1932. *Aldershot, South* cover
 title *Hindhead & District*

21 The road ahead by day EM Ten-Mile Road Map of Great Britain showing the Numbers and Classification of
 the Ministry of Transport, 1932/1935 [published 1937]

22 Black titles on brown card Covers in this section bear no coats of arms
 1 With location maps Quarter-inch England & Wales/Scotland R.A.F. Editions, 1932*
 1:500,000 Great Britain (Aeronautical Map) [cover title *Aviation Map of Great
 Britain] - R.A.F. Edition, 1937/R.A.F. Edition (War), 1940
 International Union of Geodesy and Geophysics, Map of Edinburgh, 1936
 2 No location map
 3 Filigree border▼ EM *South Wales and the Border in the Fourteenth Century*, 1933
 4 Double lineation *Sheringham District* [Six-inch map], 1936. A One-inch map is also reported

23 Hiker seated on hillside EM One-inch England & Wales Fifth Editions
 1 Red and black Fifth (Relief) Edition
 a No location map Series sheets/Special District (Relief) Maps, 1933*▽
 b With location map Series sheets, 1934*▽

20

Fifth (Relief) Edition
ORDNANCE SURVEY
ONE-INCH MAP
of England and Wales
PLYMOUTH
Mounted on Linen
Price Three Shillings Net

21

ORDNANCE SURVEY
ROAD MAP
OF GREAT BRITAIN
In two Sheets; showing Ministry
of Transport Road Classification
SCALE ~ TEN MILES TO ONE INCH
SHEET 2
Mounted on Linen ~ Price 2/9 Net

22

MOUNTED IN SECTIONS
SOUTH WALES AND
THE BORDER
IN THE
FOURTEENTH
CENTURY
BY
WILLIAM REES
SOUTH EAST SHEET
Scale : TWO MILES TO ONE INCH
PRINTED AT
THE ORDNANCE SURVEY OFFICE
SOUTHAMPTON

23

ORDNANCE SURVEY
"ONE-INCH" MAP
of England and Wales
Fifth (Relief) Edition
READING and
NEWBURY
Mounted on Linen, Price 3/- Net.
Published by the
ORDNANCE SURVEY
Southampton

24

No. ORDNANCE SURVEY MAPS
ON PLACE'S WATERPROOF PAPER
ORDNANCE SURVEY
QUARTER-INCH MAP
SHEET 10
SOUTH-WEST
ENGLAND
(New Series)
Third Edition
This map can be opened in
the rain. It is washable and
very tough and durable
Price 3/6 Net.

25

Land Utilisation Map
of England & Wales
BASED ON THE
"One-Inch" Ordnance Map
SHEET 58
CROMER
PRICE 5/- NET.
Printed and Published for the
LAND UTILISATION SURVEY OF GREAT BRITAIN
by the Ordnance Survey, Southampton.

26

ORDNANCE SURVEY
POPULATION MAP
OF GREAT BRITAIN
BASED ON THE 1931 CENSUS
SCALE 1:1,000,000
SHEET 2
ENGLAND
AND WALES
PRICE 2/3 NET
PUBLISHED BY THE DIRECTOR GENERAL
ORDNANCE SURVEY, SOUTHAMPTON

27

ORDNANCE SURVEY
OF GREAT BRITAIN
"QUARTER-INCH" MAP
FOURTH EDITION

28

ORDNANCE SURVEY
Tourist Map
DUNOON
AND
THE CLYDE
Scale: 1 Inch to 1 Mile.
PRICE
Three Shillings

29

ORDNANCE
SURVEY
DISTRICT
MAP
WORCESTER
Scale : 1 Inch to 1 Mile
Price Two Shillings & Sixpence

30

ORDNANCE SURVEY
"ONE-INCH" MAP
NORTH EAST WALES
Mounted on Linen
Price Three Shillings
Published by the Ordnance Survey Office, Southampton

31

The ORDNANCE SURVEY
DISTRICT
MAP
Scale : 1 INCH to 1 MILE

32

Ordnance Survey
Tourist Map of
SNOWDON
and DISTRICT.
Scale: 1 Inch to 1 Mile.
Mounted in Sections Price 4/Net.

33

ORDNANCE SURVEY
Tourist Map
NEW FOREST
Scale: 1 Inch to 1 Mile.
Mounted in Sections Price 4/-

34

ORDNANCE SURVEY
TOURIST MAP
NEW FOREST
SCALE 1
1-INCH to 1-MILE
Price Three Shillings Net

35

ORDNANCE SURVEY
TOURIST MAP
NEW FOREST

36

ORDNANCE SURVEY
Tourist Map of
DEESIDE
Scale: 1 Inch to 1 Mile

37

Ordnance Survey
Tourist Map of
The LAKE
DISTRICT
Scale: 1 Inch to 1 Mile.
Price Three Shillings Net

	2 Blue and black		Fifth Edition - coloured, but without relief
	a With location map		Series sheets, 1932 [published 1935]
			Special District Maps: *London*, 1937; *St Albans*, 1937 [published 1938]
	b Black sheet name		Series sheets/Special District Maps, 1939*
24	Roundel view of man in rain	EM	Maps on Place's Waterproof Paper ▽
	1 Red filigree border ▼		Quarter-inch England & Wales Third Edition (New Series), c.1933*
			Glasgow and District [Quarter-inch Special District Map], c.1933*
	2 ?Single lineation		?Half-inch Special District (Relief) Maps: *Island of Skye*, 1932; *Birmingham District*, 1933 [published 1934]
	3 Double lineation		*Norfolk Broads* [One-inch Special Sheet Popular Edition], 1932
25	Country/town scenic strips	EM	Land Utilisation Survey of Britain, 1933*. On One-inch England & Wales/Scotland Popular Edition sheets. Also published by other agencies
26	Crowd scene, rear view	EM	*Population Map based on the 1931 Census*
	1 Monochrome		Great Britain [1:1,000,000], 1934*
	2 Red sheet name and frame		*Population of Greater London* [Half-inch map], 1935 [published 1936]
27	Motorist and A51 signpost	EM	Quarter-inch England & Wales/Scotland Fourth Edition
	1 Blue and black		Series sheets, 1934. England & Wales sheet 9 was first issued with blue panels beside the location map
	2 Red and black		Series sheets of Military Edition (War Office Edition), 1939*/War Revision, 1940/Second War Revision, 1941

General purpose One-inch Tourist and District Map designs
N.B. See Nos 7 and 8

28	Three people in tourer	EM	England & Wales/Scotland Tourist Maps, 1920□. Also used on *A Description of the Ordnance Survey Small Scale Maps*, [1919]/1920/1921/1923/1925/1927
29	Black car in profile	AP	England & Wales Popular Edition District/Tourist Maps, ?1922♦
			England & Wales/Scotland Third Edition District Maps, c.1922*
30	Hiker at stile	EM	England & Wales Third/Popular Edition District Maps, c.1932* ▽
			England & Wales/Scotland Popular Edition Tourist Maps, c.1932* ▽
31	Man in plus-fours with dogs	AP	?Unused District Map design

Local views and other designs for individual maps One-inch England & Wales/Scotland Tourist Maps ▽

32	Snowdon from the east★	EM	*Snowdon District*, 1920/1925/[1938]
33	Forest scene, brown border	AP	*New Forest*, 1920□
34	Forest scene, white border	AP	*New Forest*, 1920/Fifth Edition Tourist Map, 1938 - the first "Bender" fold
35	Forest scene with oak tree	AP	?Unused design for *New Forest*
36	Bridge of Dee near Braemar	AP	*Deeside*, 1920□
37	Derwentwater from Skiddaw★	EM	*The Lake District*, 1920□/1925 △. The 1920 edition also recorded in No 29
38	Oban Station and North Pier	AP	*Oban*, 1920□/1936
39	Loch Lomond and angler★	EM	*The Trossachs & Loch Lomond*, 1920□/1929 [published 1930]/1949 △
40	Melrose Abbey from south	AP	*Scott's Country*, 1921
41	Ayr's auld brig at night	AP	*Burns' Country*, 1921
42	Scots pines in forest	AP	*Lower Strath Spey*, 1921□
43	Carisbrooke Castle	AP	*Isle of Wight*, 1921□
44	Exmoor scene, brown border	AP	*Exmoor Forest*, 1921
45	Exmoor scene with huntsman	AP	*Exmoor Forest*, 1921/Fifth Edition Special District (Relief) Map, 1936
46	London from the south★	EM	*London* [cover title *The Country round London*], 1920 [published 1922]
47	The Kyles of Bute	AP	*Rothesay & Firth of Clyde*, 1920 [published 1922]□. Some □ covers entitled *Dunoon and the Clyde*
48	Dartmoor scene	AP	*Dartmoor*, 1922/Fifth Edition Special District (Relief) Map, 1936

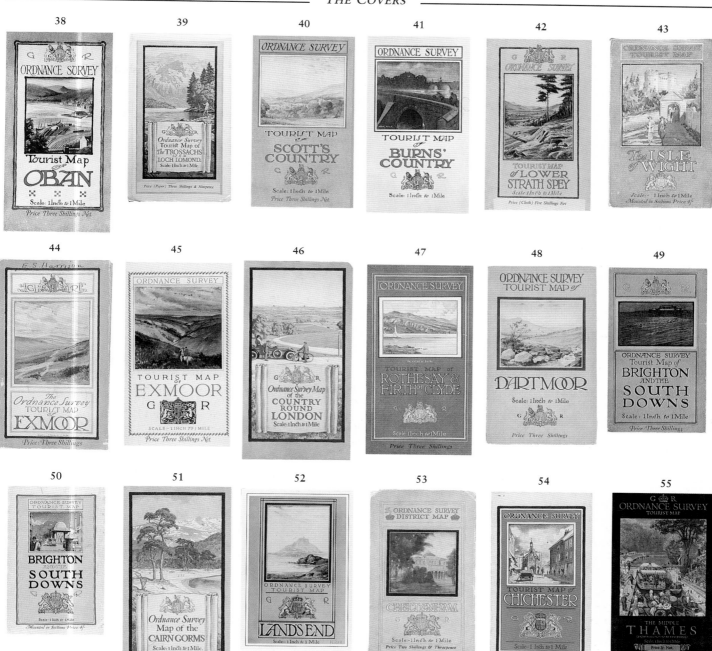

38

ORDNANCE SURVEY
Tourist Map of
OBAN
Scale: 1 Inch to 1 Mile
Price Three Shillings Net

39

Ordnance Survey
Tourist Map of
The TROSSACHS
and
LOCH LOMOND.
Scale: 1 Inch to 1 Mile
Price (Paper) Three Shillings & Ninepence

40

ORDNANCE SURVEY
TOURIST MAP
**SCOTT'S
COUNTRY**
G R
Scale: 1 Inch to 1 Mile
Price Three Shillings Net

41

ORDNANCE SURVEY
TOURIST MAP of
**BURNS'
COUNTRY**
G R
Scale: 1 Inch to 1 Mile

42

ORDNANCE SURVEY
TOURIST MAP
of LOWER
STRATH SPEY
Scale: 1 Inch to 1 Mile
Price (Cloth) Five Shillings Net

43

ORDNANCE SURVEY
TOURIST MAP
The ISLE of WIGHT
Scale: 1 Inch to 1 Mile
Mounted in Sections Price 4/-

44

E. S. Harrison
The
Ordnance Survey
TOURIST MAP of
EXMOOR
Price Three Shillings

45

ORDNANCE SURVEY
TOURIST MAP of
EXMOOR
G R
SCALE - 1 INCH TO 1 MILE
Price Three Shillings Net

46

Ordnance Survey Map
of the
**COUNTRY
ROUND
LONDON**
Scale: 1 Inch to 1 Mile
G R

47

ORDNANCE SURVEY
TOURIST MAP of
**ROTHESAY &
FIRTH of CLYDE**
G R
Scale: 1 Inch to 1 Mile
Price Three Shillings

48

ORDNANCE SURVEY
TOURIST MAP of
DARTMOOR
Scale: 1 Inch to 1 Mile
G R
Price Three Shillings

49

ORDNANCE SURVEY
Tourist Map of
**BRIGHTON
AND THE
SOUTH
DOWNS**
Scale: 1 Inch to 1 Mile
Price Three Shillings

50

ORDNANCE SURVEY
TOURIST MAP
**BRIGHTON
AND THE
SOUTH
DOWNS**
Scale: 1 Inch to 1 Mile
Mounted in Sections Price 4/-

51

Ordnance Survey
Map of the
CAIRNGORMS
Scale: 1 Inch to 1 Mile

52

ORDNANCE SURVEY
TOURIST MAP
G R
LAND'S END
Scale: 1 Inch to 1 Mile

53

ORDNANCE SURVEY
DISTRICT MAP
CHELTENHAM
G R
Scale: 1 Inch to 1 Mile
Price Two Shillings & Threepence

54

ORDNANCE SURVEY
TOURIST MAP of
CHICHESTER
G R
Scale: 1 Inch to 1 Mile
Price Three Shillings

55

G R
ORDNANCE SURVEY
TOURIST MAP
THE MIDDLE
THAMES
Scale: 1 Inch to 1 Mile
Price 3/- Net

129

49	Night bathers near West Pier	AP	*Brighton & District*, 1922
50	Indian Memorial Gateway	AP	*Brighton & District*, 1922
51	Scots pines by loch★	EM	*The Cairngorms*, 1922/1936
52	St Michael's Mount	AP	*Land's End & Lizard*, 1922
53	Pittville Spa	AP	*Cheltenham and District*, 1922, with an erroneous District Map designation
54	The Cross, Chichester	AP	*Chichester*, 1922
55	Boulter's Lock, Maidenhead	EM	*The Middle Thames*, 1923
56	Peak scene	AP	*The Peak District*, 1924
57	Dove Dale	AP	?Unused design for *The Peak District*
58	Inverness/Loch Ness views	EM	*Invergordon to Loch Ness*, 1934. Also recorded in No 30
59	Bolton Abbey	JCTW	*Ilkley District*, 1935
60	Norfolk wherry	JCTW	*Norfolk Broads*, 1932 [published 1936]
61	Highlander dismounted	EJH	*The Western Highlands*; map not published

One-inch England & Wales Popular Edition District Maps▽

62	Magdalen Bridge and Tower	AP	*Oxford and District*, 1921
63	Avon Gorge looking north	AP	*Bristol District*, 1922. Artwork with a Tourist Map designation survives
64	Liver Building	?AP	*Liverpool District*, 1924
65	River Wye from Yat Rock	EM	*Wye Valley*, 1929. Also recorded in No 29
66	Hikers descending footpath	EM	*The Chilterns*, 1932

Half-inch England & Wales Special District Maps

67	Cleeve Hill, Glos.	EM	*The Cotswolds* [(Relief) Map], 1931 [published 1932]▽
68	London area diagram	?	*Greater London* [(Relief) Map], 1935△
69	London area pictorial diagram	?	?Unused design for *Greater London* entitled *The Metropolitan Traffic Area*
70	Rock outcrop and view west	JCTW	*The Peak District*, 1936▽

Miscellaneous maps published before the Second World War

71	Foliaceous border, magenta	?	*Jersey* [Two-inch map], 1914. Post-1924 issues use the "Official" Royal Arms
72	Mont Orgueil Castle	JCTW	*Jersey* [Two-inch map], 1933 [published 1934][?▽]
73	Street scene with clock	EM	Six-inch [coloured] Town Maps, 1920
74	The arms of York	AP	*City of York* [Six-inch (coloured) Town Map], 1920
75	The River Thames at night: the view downstream from Hungerford Bridge	EM	*London* [Six-inch map], 1920* - 20 sheets lettered A-T *Central London: for the International Federation of Surveyors, 5th International Congress, Held in London, 18th-21st July, 1934*
76	Manx cat	EJH	*Isle of Man* [One-inch Popular Edition sheet 17], 1921
77	Trees with sun eclipsed	EM	*The Solar Eclipse 29th June*, 1927 [Ten-mile map]; cover title *Eclipse Map*
78	Scrollwork and highlanders	EM	*Scotland* [Ten-mile map], 1927
79	Scrollwork and compass	EM	*A Plan of Part of the Town of Cambridge for the International Geographical Congress 1928*. The design in colour was used on *A Description of the Ordnance Survey Small-Scale Maps*, 1930/1935/1937
80	The arms of Bristol [Lineation as No 8/2]	?	*British Association Topographical Map for the Bristol Meeting 1930*; cover title *British Association Bristol Meeting 1930: Excursion Map*
81	St Paul's Cathedral	EM	*"3-inch" Map of London*, 1933 - 4 sheets
82	Moulin Huet Bay	JCTW	*Guernsey* [Three-inch map], 1934△[?▽]

Period Maps

N.B. A black drawing on a thick brown paper book-fold cover is a generic feature of most of these maps. Post-war versions are usually on cream card

83	Mediaeval Winchester scene	EM	*Ancient Winchester: the Celtic Caer Gwent and Roman Venta Belgarum*, 1920
84	Roman mosaic	EM	*Roman Britain*, 1924/1928△/1956 [coloured]/1978 [published 1979; coloured]
85	Charles I and Cromwell	EM	*XVII Century England*, 1930
	Chevron and zigzag border	EM	Megalithic survey of England & Wales
86	1 Stonehenge	EM	*Neolithic Wessex*, 1932/1933. The drawing appeared c.1925

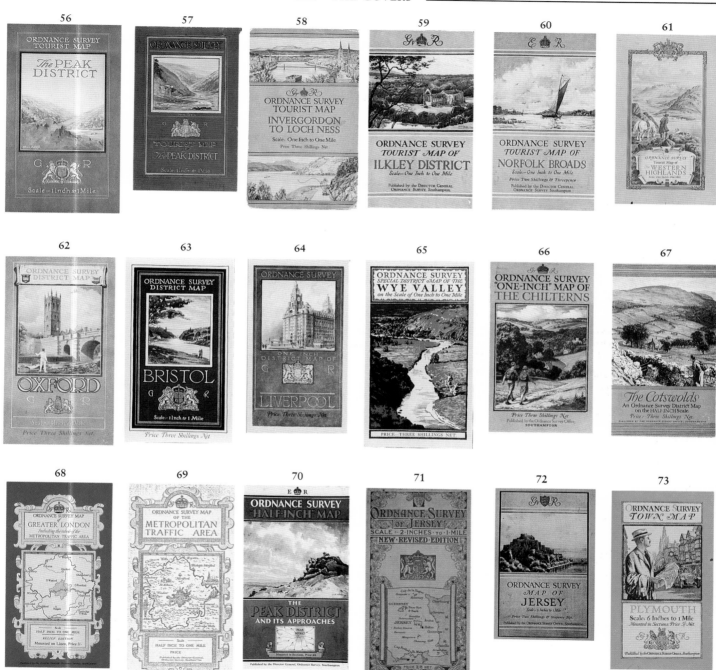

87	2 Long barrow	EM	*The Trent Basin Showing the distribution of Long Barrows, Megaliths and Habitation-sites*, 1933
88	3 Gors Fawr stone circle and Presely Mountains	?	*South Wales Showing the distribution of Long Barrows and Megaliths*, 1936. Based on a photograph in *An Inventory of the Ancient Monuments in Wales . . . : Vol. 7 Pembrokeshire* [London, 1925, opposite p.243]
89	Ox ploughing	EM	*Celtic Earthworks of Salisbury Plain based on Air Photographs*. Only one of six sheets published: *Old Sarum*, 1933 [published 1934]/1937
90	Statue of Augustus	EM	*Tabula Imperii Romani* sheets, 1940-1969. The drawing was made in 1934
	Lindisfarne bird border	EM	*Britain in the Dark Ages (South Sheet)*, 1935
91	1 Roman fort and Saxons		The published design based on a drawing in a ninth century Utrecht Psalter △
92	2 "The Arryval of the First Anceters"		Unused design reproduced from Richard Verstegan *A Restitution of Decayed Intelligence . . .* [Antwerp, 1605]
93	Invergowrie grave-slab	RAJ	*Britain in the Dark Ages (North Sheet)*, 1938 [published 1939] △
94	Turf wall and Trimontium	RAJ	*Scotland in Roman Times*, 1940; cover title *The Forth Clyde and Tay: Roman Period*. The wall and turret taken from a model by William Bulmer
95	Fort and wall building	YM	*The Border (Roman Period)*; map not published. A scraper-board design inspired by scenes on Trajan's Column as depicted in Conrad Cichorius *Die Reliefs der Traianssaüle* [Berlin, 1896, plates 15 and 46]

THE POST-WAR YEARS FROM 1945
Ordnance Survey of Great Britain standard cover design, 1940○

Martin created this design, featuring a border of wavy lines, usually with the "Medallion" Royal Arms, for the One-inch New Popular Edition planned for publication in 1940. It became the first standard post-war cover design. The medallion's first known appearance was in blue on the Ordnance Survey 1937 Christmas card. It was redrawn on new post-1953 covers. Most covers are on cream card. Quarter-inch and Scotland One-inch maps retain hinged covers. N.B. See No 194

96	1 Red border		
	a "Medallion" Royal Arms		
	1 With hand-lettering	EM	One-inch Great Britain New Popular Edition, 1940 [published 1945]: sheets 157, 158, 161, 167, 169, 171, 172, 179, 182, 183, 184 only. Sheet 179's cover was drawn first with "National Grid" below the medallion
	2 In letterpress		One-inch Great Britain New Popular Edition, 1945* "Ten Mile" Map of Great Britain, 1962-1963
	3 Buff card		"Ten Mile" Map of Great Britain, 1955 [published 1956]/1958-1960
	b Scottish lion rampant		One-inch Scotland Popular Edition (with National Grid), 1945
	2 Blue border		
	a Long format		Quarter-inch England & Wales/Scotland Fourth Edition (National Grid), 1945. In letterpress: Martin's hand-lettered original was never used
	b Standard format		
	1 Buff card		*Roads*, 1956; cover title *The Ten-Mile Road Map of Great Britain*
	2 Cream card		*Isles of Scilly* [Two-inch Special District (Relief) Map, 1933], 1959*
	3 Brown border		*Roads*, 1946; cover title *The Ten-Mile Road Map of Great Britain* *Throughway Map of London* [One-inch map] *Printed Back to Back with Central London* [Three-inch map]; publication in 1947 cancelled
	4 Olive border		*The Lake District* [One-inch Tourist Map, 1925], 1947* *Jersey* [Two-inch map, 1933], 1947* *Guernsey* [Three-inch map, 1934], 1947* *Isle of Man* [One-inch England & Wales Second War Revision sheet 17, 1942], with Cassini Grid, c.1948*/with National Grid, 1950
	5 Green border		*Guernsey* [Three-inch map, with Universal Transverse Mercator Grid], 1958

74

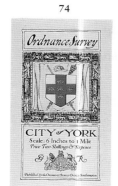

75

76

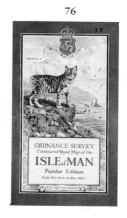

77

78

79

80

81

82

83

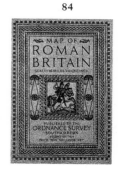

84

85

85 image

86

87

88

89

90

91

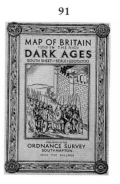

133

One-inch Tourist Map
Based on Great Britain New Popular Edition material

97	Loweswater and Carling Knott	AF	*The Lake District*, 1948; a photograph from *The English Lakes* (London, 1948, plate 71). Five of the original's seven sheep were deleted, but two were reinstated later. Also considered was a view of Blea Tarn

Post-war Ordnance Survey of Great Britain standard designs
The first post-war designs for Great Britain map covers and Ordnance Survey publicity material were the results of internal staff competitions. Those used or developed for use coincidentally featured graduated parallel lines or borders, usually black, separating the map title panel from the background colour. Reynolds Stone's new Royal and Scottish Arms for Queen Elizabeth II were incorporated in 1956

98	Six lines, with index map	CIV	1:25,000 Provisional Edition
	1 Black and blue on buff		Series sheets [cloth/paper maps], 1945; several minor design changes ensued
	2 Black and blue on cream		Series sheets [paper maps], 1950*
99	Five lines, stepped	SPR	Other Great Britain series sheets
	1 Black and red		One-inch Seventh Series, 1952. The length of cover extended by 20mm, 1960* ▶
	2 Black and olive		Half-inch Provisional Edition sheet 51, 1956
			Half-inch Second Series sheet 36, 1958; sheets 28, 39, 1961
	3a Black and blue on buff		Quarter-inch Fifth Series [1:250,000] sheet 10, 1957
	b Black and blue on cream		Quarter-inch Fifth Series [1:250,000] series sheets, 1960*. [A few ●]
100	Five lines, landscape format	?SPR	Great Britain Special Maps
	1a Black and red		One-inch Tourist Maps: *The Peak District*, 1957; *The Lake District*, 1958; *Lorn and Lochaber*, 1959; *Loch Lomond and the Trossachs, Wye Valley and Lower Severn*, 1961; *North York Moors*, c.1961*
	b The Royal Arms in frame		*The Peak District*, 1963, and the other One-inch Tourist Maps, 1963*. *Lorn and Lochaber* cover was renamed *Ben Nevis & Glen Coe*, 1964
	c Portrait format		*North York Moors* [One-inch Tourist Map], 1958
	2 Red Welsh dragon and blue		*Wales and the Marches* [Quarter-inch Fifth Series Special Sheet], 1959 ▶ /1963
	3a Black and olive		Half-inch Provisional Edition/Second Series sheets 28, 36, 39, *Greater London* [43], 51 in Half-inch District Map covers, 1962*
	b The Royal Arms in frame		The same Half-inch sheets in District Map covers, 1963*

Other contemporary covers

101	1 Ansell-fold, yellow boards		*The Ten Mile Road Map of Great Britain*, 1946 ▲
	2 Ansell-fold, khaki boards		*The Ten Mile Road Map of Great Britain*, 1948* ▲
102	Green on buff card		*Richmond Park*, 1949; *St James's & The Green Parks*, 1953
103	Green on paper		*Richmond Park*, 1962●; *Bushy Park & Hampton Court Gardens & Park*, 1964●
104	Green check		*Regent's Park & Primrose Hill*, 1961
105	The Palm House	RASH	*The Royal Botanic Gardens Kew*, 1962●/1963●/1972●/1974●
106	Pink panels		*Ministry of Transport Through Route Map of London Area* [One-inch map], 1955*
107	Blue panels		1:25,000 Provisional Edition, 1955*/First Series, 1956
			Ilfracombe [1:25,000 Provisional Edition sheet 856], 1960●. Renamed *Ilfracombe and Lundy* c.1967* ●

Ordnance Survey House Style, 1963
First seen on the *Ordnance Survey Publication Report* of January 1963 was the new cover style designed for Ordnance Survey by Reeves, the consistent feature of which was Reynolds Stone's coat of arms (either the Royal or the Scottish Arms) in the top left-hand corner of the map cover on an upright oblong, usually black, background. Covers were laminated as standard practice from late 1965. See No 183

108	Great Britain diagram, dated	?SPR	1:625,000 Route Planning Map 1964-1968. 1965-1966 covers with "Dayglo"
109	1 Area diagram, blue/olive	SPR	*Isles of Scilly* [1:25,000 Provisional Edition], 1964
	2 Area diagram, blue/emerald	SPR	*Isles of Scilly* [1:25,000 Provisional Edition], 1966*

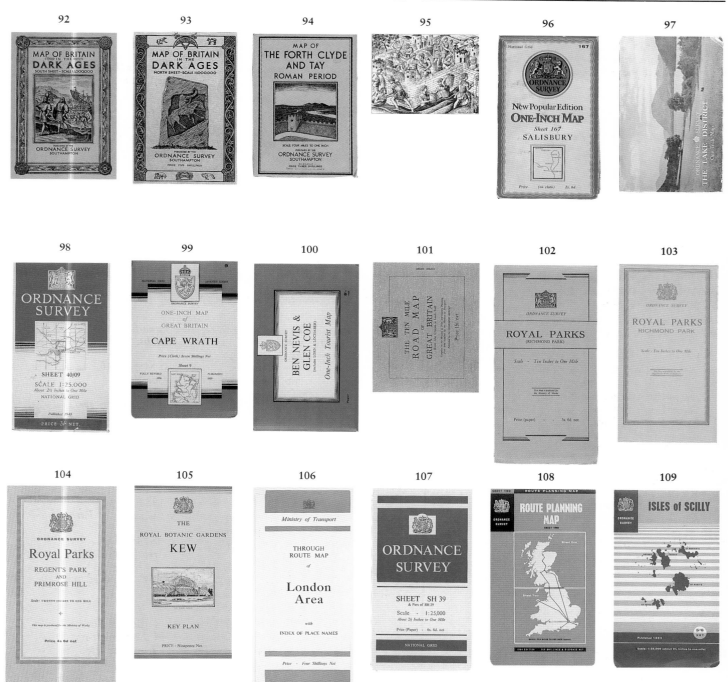

92

93

94

95

96

97

98

99

100

101

102

103

104

105

106

107

108

109

110	Area diagram over red tartan	SPR	*Cairngorms* [One-inch Tourist Map], 1964▶
111	1 Red Welsh dragon, grey	SPR	*Wales and the Marches* [Quarter-inch Fifth Series Special Sheet], 1965*▶
	2 Red Welsh dragon, green	SPR	*Wales and the Marches* [Quarter-inch Fifth Series Special Sheet], 1967*
112	Seventeen location maps, blue	SPR	Quarter-inch Fifth Series, 1965*▶◊
113	1 Magnifying glass, blue	?SPR	1:25,000 First Series, 1965*▶
	2 Magnifying glass, green	?SPR	1:25,000 Second Series, 1965▶
114	Black college badges, blue	SPR	*Cambridge* [One-inch Tourist Map], 1965
115	Area diagram, turquoise	SPR	*Greater London* [Half-inch District Map], 1965*▶; cover title *London and surrounding areas*. "Published 1962" deleted from later covers
116	Black area diagram, red	SPR	*New Forest* [One-inch Tourist Map], 1966
117	Red area diagram, grey	SPR	*Lake District* [One-inch Tourist Map], 1966
118	Area diagram, turquoise	SPR	*Snowdonia National Park* [Half-inch District Map/Half-inch map], 1966
119	Island diagram, azure/blue	SPR	*Guernsey* [Three-inch map, with Universal Transverse Mercator Grid], 1966
120	Stippled area diagram, mauve	SPR	*North York Moors* [One-inch Tourist Map], 1966
121	Trafalgar Square, St Paul's Cathedral, red/blue/black	SPR	*Greater London* [One-inch Special Map], 1967▽
122	Rock formations, green	SPR	*The Peak District* [One-inch Tourist Map], 1967*
123	Twelve panels, red/blue/black	SPR	*Loch Lomond and the Trossachs* [One-inch Tourist Map], 1967*
124	Pony [Dartmoor logo], red	SPR	*Dartmoor* [One-inch Tourist Map], 1967
125	Antlers [Exmoor logo], grey	SPR	*Exmoor* [One-inch Tourist Map], 1967
126	Scotland, black/olive/orange	SPR	*Ben Nevis and Glen Coe* [One-inch Tourist Map], 1968*

Ordnance Survey House Style, 1968

The new Ordnance Survey colophon, a north-pointing crossed arrow between the letters O and S, representing both a bench mark and a magnetic needle, was developed by the Central Office of Information and made its first appearance on the *Ordnance Survey Publication Report* for January 1969. It was gradually incorporated into all map cover designs and remains in use at the time of writing. A white frame surrounds location map or illustration

	Dated covers, various colours		1:625,000 Route Planning Maps [Routeplanner from 1980]
127	Great Britain diagram		1969-1974 [published annually 1968-1973]
128	Motorway junction		1975-1979 [published annually 1974-1978]
129	Triumph Dolomite		1980 [published 1979]
130	Jaguar XJ Coupé		1981 [published 1980]
131	Austin Metro		1982 [published 1981]
132	One colour covers		Series sheets, the covers of various dimensions, usually with location map
	1 Red		One-inch Seventh Series, 1969*
	2 Dark blue		Quarter-inch Fifth Series, 1970*
	3 Blue, no location map		1:25,000 First Series, 1970*●
	4 Green		1:25,000 Second Series, 1971* [Pathfinder Series from 1980]
	5 Blue		1:25,000 Provisional Edition *Isles of Scilly*, 1972* [First Series on cover]
	6 Light blue		1:25,000 First Series *Isles of Scilly*, 1974
	7 Magenta		1:50,000 First Series/Second Series, 1974 [Landranger Series from 1980]
	Local views on black covers		One-inch Tourist Maps, unless listed otherwise
133	Ashness Bridge, Derwent Water		*Lake District*, 1970*. The illustration was printed back to front!
134	Blea Tarn and Langdale Pikes		*Lake District*, 1971*
135	Winnatts Pass near Castleton		*Peak District*, 1970*
136	St Hilda's Abbey, Whitby		*North York Moors*, 1970*
137	The Tower of London	NJ	*Greater London* [One-inch Special Map], 1971
138	St David's Cathedral		*Wales and the Marches* [Quarter-inch Fifth Series Special Sheet], 1971/1976
139	New Forest ponies		*New Forest*, 1972 [published 1973]
140	Harlech Castle		*Snowdonia National Park* [Half-inch map], 1973*

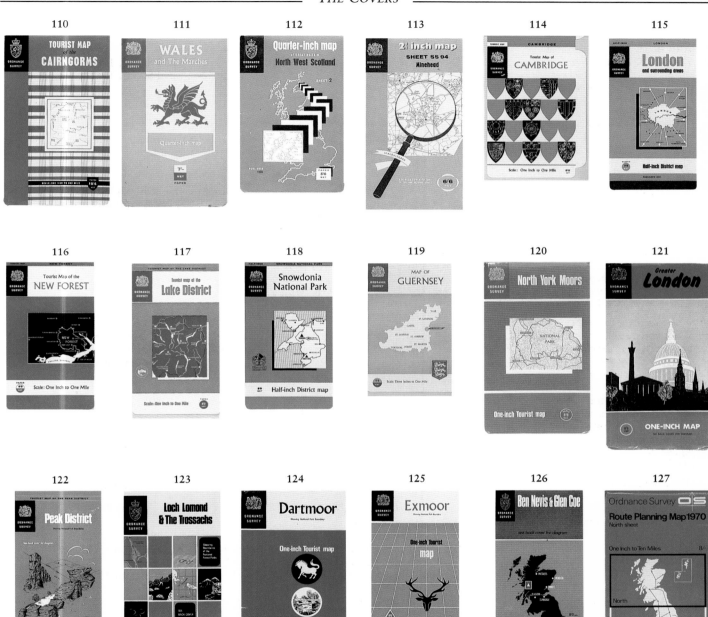

141	Tarr Steps		*Exmoor*, 1973
142	The Three Sisters, Glen Coe		*Ben Nevis & Glen Coe*, 1973*
143	Hay Tor		*Dartmoor*, 1973
144	Granite rocks and stag		*Cairngorms*, 1973*
145	Trossachs Pier, Loch Katrine		*Loch Lomond and the Trossachs*, 1974*
	Birds on brown/yellow covers		First/Second Series 1:25,000 Outdoor Leisure Maps
146	1 Ring ousel, brown	HT	*The Dark Peak*, 1972▽
	2 Ring ousel, yellow	HT	*The Dark Peak*, 1983 [published 1984]
147	Curlew, brown	HT	*The Three Peaks*, 1973
148	Capercaillie, yellow	HT	*High Tops of the Cairngorms*, 1974; renamed *Aviemore and the Cairngorms*, 1982
149	1 Raven, brown	HT	*The English Lakes*, 1974 - 4 sheets [NW, NE, SE sheets▽]
	2 Raven, yellow	HT	*The English Lakes*, 1982 - 4 sheets
150	Golden eagle, yellow	HT	*The Cuillin Hills/The Torridon Hills*, 1975▽
151	Skylark, yellow	HT	*Brighton and Sussex Vale*, 1975
152	House martin, brown	HT	*Malham and Upper Wharfedale*, 1975 [published 1976]▽
153	Buzzard, brown	HT	*Brecon Beacons National Park*, 1976 - 3 sheets
154	Kingfisher, brown	HT	*Wye Valley and Forest of Dean*, 1977▽
155	Dartford warbler, yellow	HT	*Purbeck*, 1977
156	Jay, brown	HT	*Snowdonia National Park*, 1977 - 4 sheets [2 published in 1978]
157	Dipper	HT	Unused drawing for *Snowdonia National Park: Conwy Valley*, 1977
158	Oystercatcher, yellow	HT	*South Devon*, 1978
159	1 Twite, brown	HT	*South Pennines*, 1978
	2 Twite, yellow	HT	*South Pennines*, 1984
160	Hobby, yellow	HT	*New Forest*, 1979▽
161	Cormorant, brown	HT	*Snowdonia National Park: Cader Idris/Dovey Forest*, 1979▽
162	Wheatear, yellow	HT	*The White Peak*, 1980
163	Puffin, yellow	HT	*Isles of Scilly*, 1982●
164	Red grouse, yellow	HT	*North York Moors*, 1982 [published 1983] - 2 sheets
165	Whinchat	HT	Unused drawing for *Dartmoor*, 1984. Superseded by photographic cover
166	Mute swan	HT	Unused drawing intended for the unpublished *Thames Valley*

Official Leisure Maps

167	La Corbière lighthouse	FS	*Jersey* [1:25,000], 1982
168	Island diagram and puffins	GM	*Alderney* [Six-inch map], 1988●

1:10,000 District and Neighbourhood Maps●
N.B. Maps of this type with photograph covers are ignored here

169	Sailing on the Solent	GM	*Isle of Wight Towns Neighbourhood Map*, 1982
170	New Forest pony and foal	GM	*Ringwood, Wimborne and Ferndown Neighbourhood Map*, 1982
171	High Street, Crawley	GM	*Horsham, East Grinstead, Haywards Heath & Crawley Neighbourhood Map*, 1984
172	Market Street	GM	*Carnforth Neighbourhood Map*, 1984
173	Main Street, Coatbridge	CL	*Monklands District Map*, 1985
174	Town centre	CL	*Chester-le-Street District Map*, 1986

Post-war Period Maps

175	Glastonbury Abbey seal	RAJ	*Monastic Britain (North Sheet)/(South Sheet)*, 1950/1954-1955. In letterpress. Publication of the south sheet in 1940 was cancelled. Thus Jerrard's 1939 hand-lettered original was never used
176	Arbroath Abbey	ATC	*Monastic Britain North Sheet*, 1965*
177	Byland Abbey	ATC	*Monastic Britain South Sheet*, 1965*
178	Seal of the Church of Christ at Canterbury	COI	*Monastic Britain*, 1976

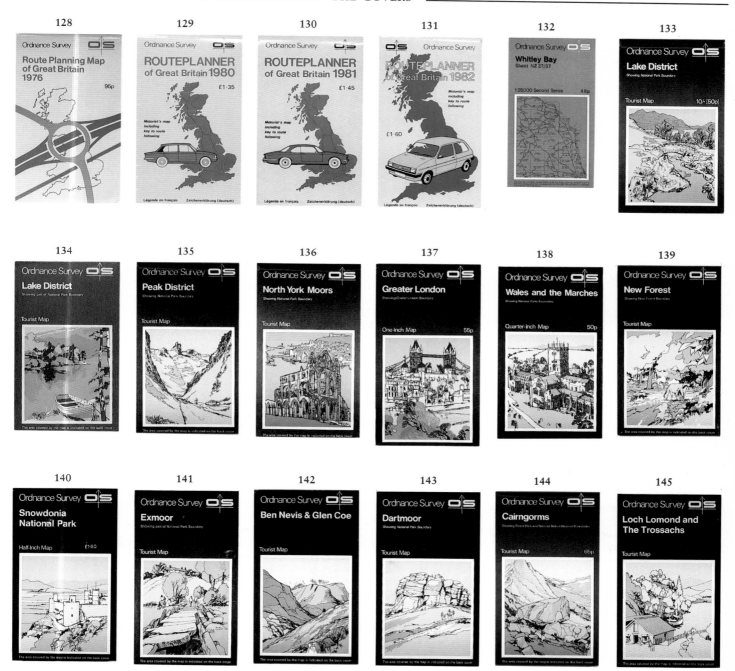

128 — Ordnance Survey — Route Planning Map of Great Britain 1976 — 95p

129 — Ordnance Survey — ROUTEPLANNER of Great Britain 1980 — £1·35 — Motorist's map including key to route following — Légende en français — Zeichenerklärung (deutsch)

130 — Ordnance Survey — ROUTEPLANNER of Great Britain 1981 — £1·45 — Motorist's map including key to route following — Légende en français — Zeichenerklärung (deutsch)

131 — OS — Ordnance Survey — ROUTEPLANNER of Great Britain 1982 — £1·60 — Motorist's map including key to route following — Légende en français — Zeichenerklärung (deutsch)

132 — Ordnance Survey — Whitley Bay — Sheet NZ 27/37 — 1:25000 Second Series — 48p

133 — Ordnance Survey — Lake District — Showing National Park Boundary — Tourist Map — 10/- [50p]

134 — Ordnance Survey — Lake District — Showing part of National Park Boundary — Tourist Map — The area covered by the map is indicated on the back cover

135 — Ordnance Survey — Peak District — Showing National Park Boundary — Tourist Map — The area covered by the map is indicated on the back cover

136 — Ordnance Survey — North York Moors — Showing National Park Boundary — Tourist Map — The area covered by the map is indicated on the back cover

137 — Ordnance Survey — Greater London — Showing Greater London Boundary — One-Inch Map — 55p

138 — Ordnance Survey — Wales and the Marches — Showing National Parks Boundaries — Quarter-Inch Map — 50p

139 — Ordnance Survey — New Forest — Showing New Forest Boundary — Tourist Map — The area covered by the map is indicated on the back cover

140 — Ordnance Survey — Snowdonia National Park — Half-Inch Map — £1·60

141 — Ordnance Survey — Exmoor — Showing part of National Park Boundary — Tourist Map — The area covered by the map is indicated on the back cover

142 — Ordnance Survey — Ben Nevis & Glen Coe — Tourist Map — The area covered by the map is indicated on the back cover

143 — Ordnance Survey — Dartmoor — Showing National Park Boundary — Tourist Map — The area covered by the map is indicated on the back cover

144 — Ordnance Survey — Cairngorms — Showing Forest Park and National Nature Reserve Boundaries — Tourist Map — 65p — The area covered by the map is indicated on the back cover

145 — Ordnance Survey — Loch Lomond and The Trossachs — Tourist Map — The area covered by the map is indicated on the back cover

179	1 Stonehenge trilith, cream	ATC	_Ancient Britain (North Sheet)/(South Sheet)_, 1951
	2 Stonehenge trilith, puce	ATC	_Ancient Britain (South Sheet)_, 1964 [published 1965]
180	Ruined broch	ATC	_Ancient Britain (North Sheet)_, 1964 [published 1965]
181	Trophy of arms	BHT	_Southern Britain in the Iron Age_, 1962
	Sestertius of Hadrian		
182	Both faces, landscape format	ATC	_Hadrian's Wall_, 1964
183	Both faces, portrait format	ATC	_Hadrian's Wall_, 1967*; in the 1963 house style, q.v.
184	1 The head of a coin	ATC	_Hadrian's Wall_, 1972 [published 1973]
	2 The head of another coin	ATC	_Hadrian's Wall_, 1975*
185	Sutton Hoo helmet	ATC	_Britain in the Dark Ages_, 1966
186	Sestertius of Antoninus Pius	ATC	_The Antonine Wall_, 1969●
187	King Alfred jewel	COI	_Britain before the Norman Conquest_, 1973 [published 1974]

Photographs were introduced to map covers in 1978 on 1:250,000 Routemaster Series sheets published to replace the Quarter-inch Fifth Series. Since then, photograph covers have been applied to Routeplanner Maps, Holiday/Touring Maps & Guides, Tourist, Landranger, Outdoor Leisure, and 1:10,000 Town, City and District Maps, as well as special maps such as _Maritime England_, 1982, the _M25 & London Map_, 1986, and some Period Maps. The other current cover convention is to employ coloured location maps. These appear on the 1:25,000 Pathfinder Series, other City Link Maps, and have experimentally been used on some of the 1:50,000 Landranger Series maps beginning with sheet 103

Ordnance Survey undertakes commissions for standard maps, perhaps overprinted, inside special covers. These have not been listed here, but an example is the yellow AA cover applied to the 1965-1967 editions of the Route Planning Map. Its work has also been published in the covers of other agencies, and a few examples are given here:

188	"Bridges' Patent Mounting" [at least four variants]	?	Stanford covers applied to One-inch Popular Edition series sheets/Tourist/District maps, Half-inch layered/MOT/Quarter-inch series sheets
189	Index map of Great Britain with AA logo	?	Automobile Association and Royal Aero Club General Flying Map [First Series], 1929/Second Series, 1934 - Quarter-inch Civil Air Editions
190	Oxford viewed from Hinksey	?	_Oxford and District Footpaths, Bridlepaths, and Commons Preservation Society_
	1 Black on brown		Two-inch map, 1933
	2 Black on olive		Two-inch map, 1945*
191	London landmarks	?	_London Lightning Plan_ ["3-inch" Map of London, 1933, in strip format], 1934
192	University/town arms	?	_Cambridge and District Footpaths Map_ [Two-inch map], 1936/?1945*
193	Geologists inland○	KTK	Geological Survey Maps
	1 Squared border, brown		"One-inch" England & Wales/?Scotland series sheets, c.1937*
194	Geologists near coast○	KTK	Geological Survey Maps. See No 96
	1 Squared border, green		"Quarter-inch" England & Wales/?Scotland series sheets, c.1937*
	2 Wavy border, olive		"Ten-Mile" Map of Great Britain, 1948/1957/1964▶
	3 Wavy border, magenta		"Ten-Mile" Map of Great Britain, 1964▶. With index overprint
195	The arms of the two islands	?	1:50,000 Trinidad and Tobago series sheets, 1926
			Trinidad [1:150,000], 1930
196	Peristerona	FJS	Eighth-inch Survey of Cyprus Motor Map, 1931
			One-inch Survey of Cyprus Visitors' Maps
197	St Hilarion Castle	FJS	_Kyrenia_, 1931
198	Mountain View [?Troödos]	FJS	_Troödos and the Hill Resorts_, 1932
199	Window in St Hilarion Castle	FJS	Quarter-inch Survey of Cyprus Administration Map, 1932△

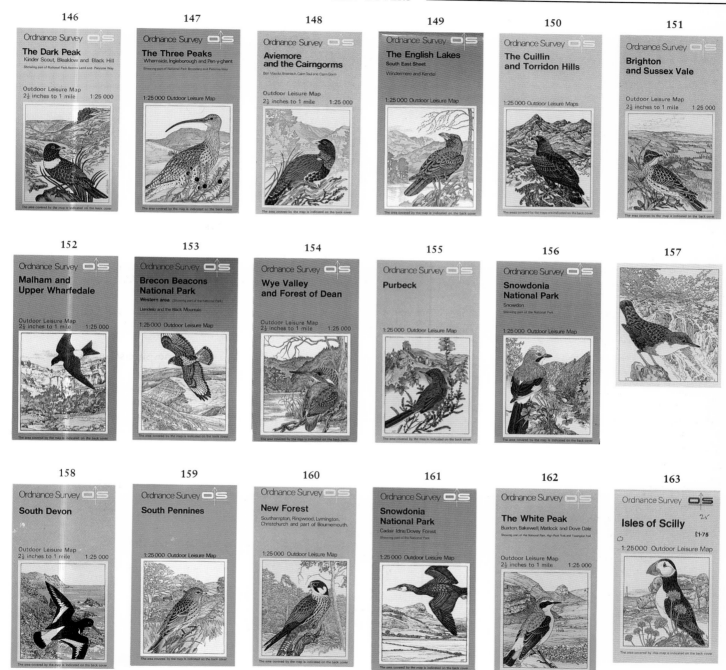

146 — Ordnance Survey OS — The Dark Peak — Kinder Scout, Bleaklow and Black Hill — Showing part of National Park Access Land and Pennine Way — Outdoor Leisure Map — 2½ inches to 1 mile — 1:25 000 — The area covered by the map is indicated on the back cover

147 — Ordnance Survey OS — The Three Peaks — Whernside, Ingleborough and Pen-y-ghent — Showing part of National Park Boundary and Pennine Way — 1:25 000 Outdoor Leisure Map — The area covered by the map is indicated on the back cover

148 — Ordnance Survey OS — Aviemore and the Cairngorms — Ben Macdui, Braeriach, Cairn Toul and Cairn Gorm — Outdoor Leisure Map — 2½ inches to 1 mile — 1:25 000 — The area covered by the map is indicated on the back cover

149 — Ordnance Survey OS — The English Lakes — South East Sheet — Windermere and Kendal — 1:25 000 Outdoor Leisure Map — The area covered by the map is indicated on the back cover

150 — Ordnance Survey OS — The Cuillin and Torridon Hills — 1:25 000 Outdoor Leisure Maps — The areas covered by the maps are indicated on the back cover

151 — Ordnance Survey OS — Brighton and Sussex Vale — Outdoor Leisure Map — 2½ inches to 1 mile — 1:25 000 — The area covered by the map is indicated on the back cover

152 — Ordnance Survey OS — Malham and Upper Wharfedale — Outdoor Leisure Map — 2½ inches to 1 mile — 1:25 000 — The area covered by the map is indicated on the back cover

153 — Ordnance Survey OS — Brecon Beacons National Park — Western area (Showing part of the National Park) — Llandeilo and the Black Mountain — 1:25 000 Outdoor Leisure Map — The area covered by the map is indicated on the back cover

154 — Ordnance Survey OS — Wye Valley and Forest of Dean — Outdoor Leisure Map — 2½ inches to 1 mile — 1:25 000 — The area covered by the map is indicated on the back cover

155 — Ordnance Survey OS — Purbeck — 1:25 000 Outdoor Leisure Map

156 — Ordnance Survey OS — Snowdonia National Park — Snowdon — Showing part of the National Park — 1:25 000 Outdoor Leisure Map — The area covered by the map is indicated on the back cover

157

158 — Ordnance Survey OS — South Devon — Outdoor Leisure Map — 2½ inches to 1 mile — 1:25 000 — The area covered by the map is indicated on the back cover

159 — Ordnance Survey OS — South Pennines — 1:25 000 Outdoor Leisure Map — The area covered by the map is indicated on the back cover

160 — Ordnance Survey OS — New Forest — Southampton, Ringwood, Lymington, Christchurch and part of Bournemouth. — 1:25 000 Outdoor Leisure Map — The area covered by the map is indicated on the back cover

161 — Ordnance Survey OS — Snowdonia National Park — Cadair Idris/Dovey Forest — Showing part of the National Park — 1:25 000 Outdoor Leisure Map — The area covered by the map is indicated on the back cover

162 — Ordnance Survey OS — The White Peak — Buxton, Bakewell, Matlock and Dove Dale — Showing part of the National Park, High Peak Trail and Tissington Trail — Outdoor Leisure Map — 2½ inches to 1 mile — 1:25 000 — The area covered by the map is indicated on the back cover

163 — Ordnance Survey OS — Isles of Scilly — £1·75 — 1:25000 Outdoor Leisure Map — The area covered by this map is indicated on the back cover

164

165

166

167

168

169

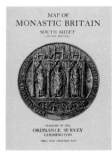

170

171

172

173

174

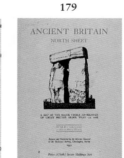

175

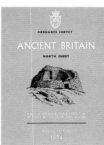

176

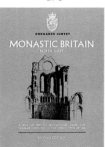

177

178

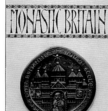

179

180

181

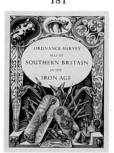

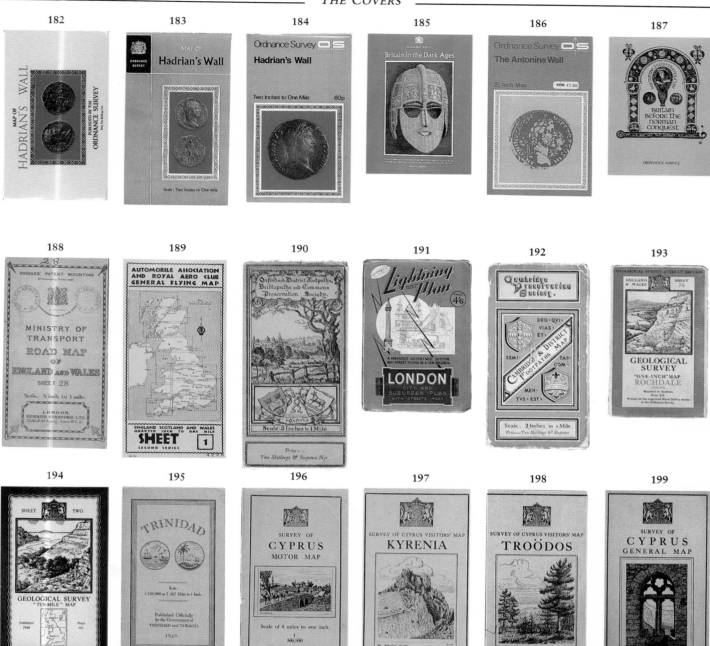

182 183 184 185 186 187

188 189 190 191 192 193

194 195 196 197 198 199

Notes

○ Cover designs also recorded on Geological Survey maps at 25 miles to the inch, and at quarter-inch and one-inch scales

●Integral or direct printed covers. These were never laminated

□Maps on which cover No 28 has been recorded, presumably before the individual covers had been prepared

★These cover designs are uniform in that each is bordered by a black frame, with its title written on a scroll

◊These maps also issued in atlases. 13/1a: *England & Wales*, 1922, and *Scotland*, 1924, both in maroon cloth binding, and *Great Britain*, 1924 in green half leather binding. All titles with gold lettering, possibly designed by Arthur Palmer. No 112 appeared in loose-leaf atlas form in 1967

◆ Some titles (eg *London (North)/(South)*) with superscription "Special Sheet Popular Edition", doubtless to distinguish them from similarly named Third Edition sheets which had also appeared in this cover before being superseded

△ These cover designs remained in use after 1945, sometimes until the maps themselves were superseded

▽ The waterproofing method invented by Colonel C. O. Place of the Royal Engineers involved impregnating a special paper with a solution that permeated it completely. First used by Ordnance Survey in about 1929, the technique was applied both to military and civilian maps. Usually map covers either bore a legend referring to the waterproof paper, or were adorned by the colophon that Martin designed in 1929 to advertise the product, a roundel view of a man map-reading in pouring rain (see No 24). Later methods of waterproofing maps tried by Ordnance Survey included the "new water-resisting paper" used experimentally on the 1936 Half-inch map *The Peak District* (No 70), "Syntosil" paper on the 1967 *Greater London* One-inch map (No 121), and "Polyart" tear and water resistant material on nine Outdoor Leisure maps from July 1980 (Nos 146, 149, 150, 152, 154, 160, 161). The latest method was first applied to the Mountainmaster of *Ben Nevis* (Outdoor Leisure 32●) in 1989. Most covers incorporate a note reflecting the special quality of the map inside

▲ Major G. K. Ansell of the Inniskillings devised a patent system of back-to-back map folding which was copyrighted by Stanford's in January 1906. It was used by Ordnance Survey in the 1930s, and again immediately after the war, mainly on maps intended for use in the car

▼ The filigree border used on these maps also appears in *A Description of the Ordnance Survey Small-Scale Maps*, 1935

► Covers which have been recorded in both unlaminated and laminated versions

The Artists

ATC	Arthur Thomas Chester
AF	Alfred Furness [photographer]
BHT	Brian Hope-Taylor
RASH	Reginald Augustus Schubert Horner
EJH	Edward John Hoy
MJ	M. Jackson
RAJ	Reginald Arthur Jerrard
KTK	unidentified
CL	Christine Lewis
EM	Ellis Martin
GM	Gary Meadows
YM	Yolande Moden
AP	Arthur Palmer
SPR	Stanley Phillip Reeves
FJS	Frederick J. Salmons
FS	Frederick Sands
HT	Harry Titcombe
CIV	C. I. Vann
JCTW	John Christopher Temple Willis
COI	Central Office of Information